Ninja Coloring Book : Warrior Ninjas in Action

Copyright © 2024 by Ninja GO
All rights reserved.

No part of this publication may be reproduced, distributed, or transmitted in any form or by any means, including photocopying, recording, or other electronic or mechanical methods, without the prior written permission of the publisher, except as permitted by copyright law.

This Book Belongs to

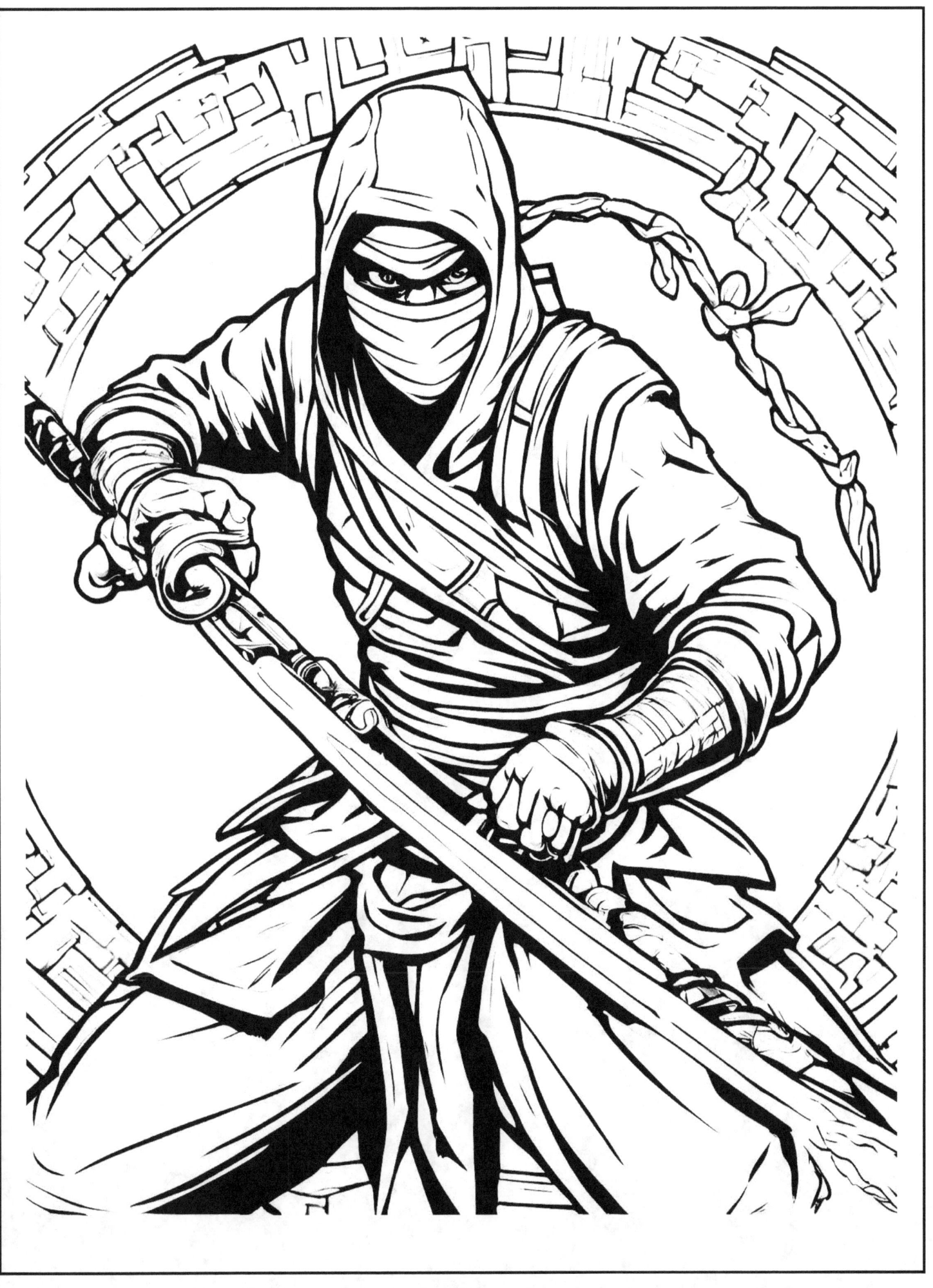

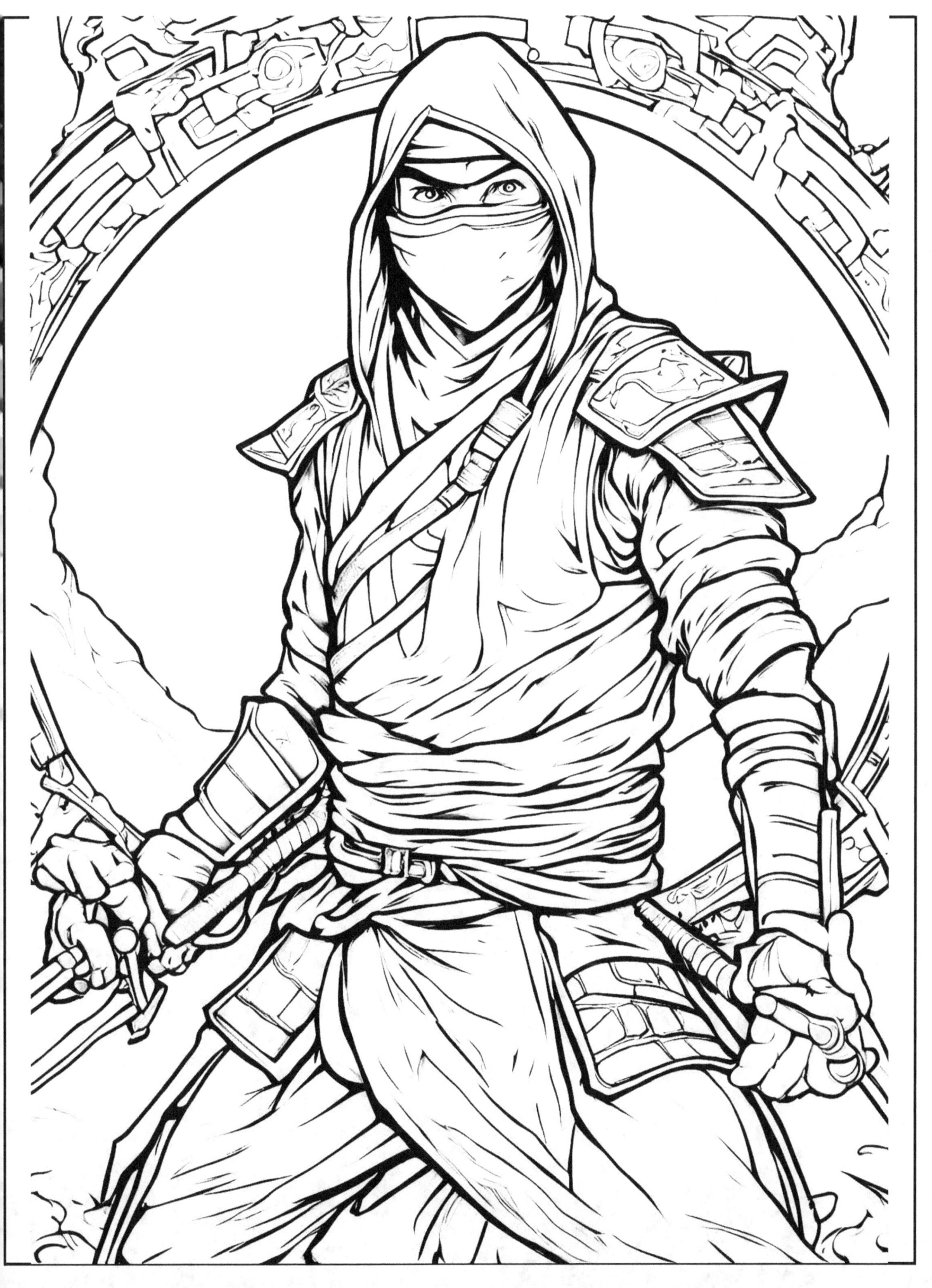

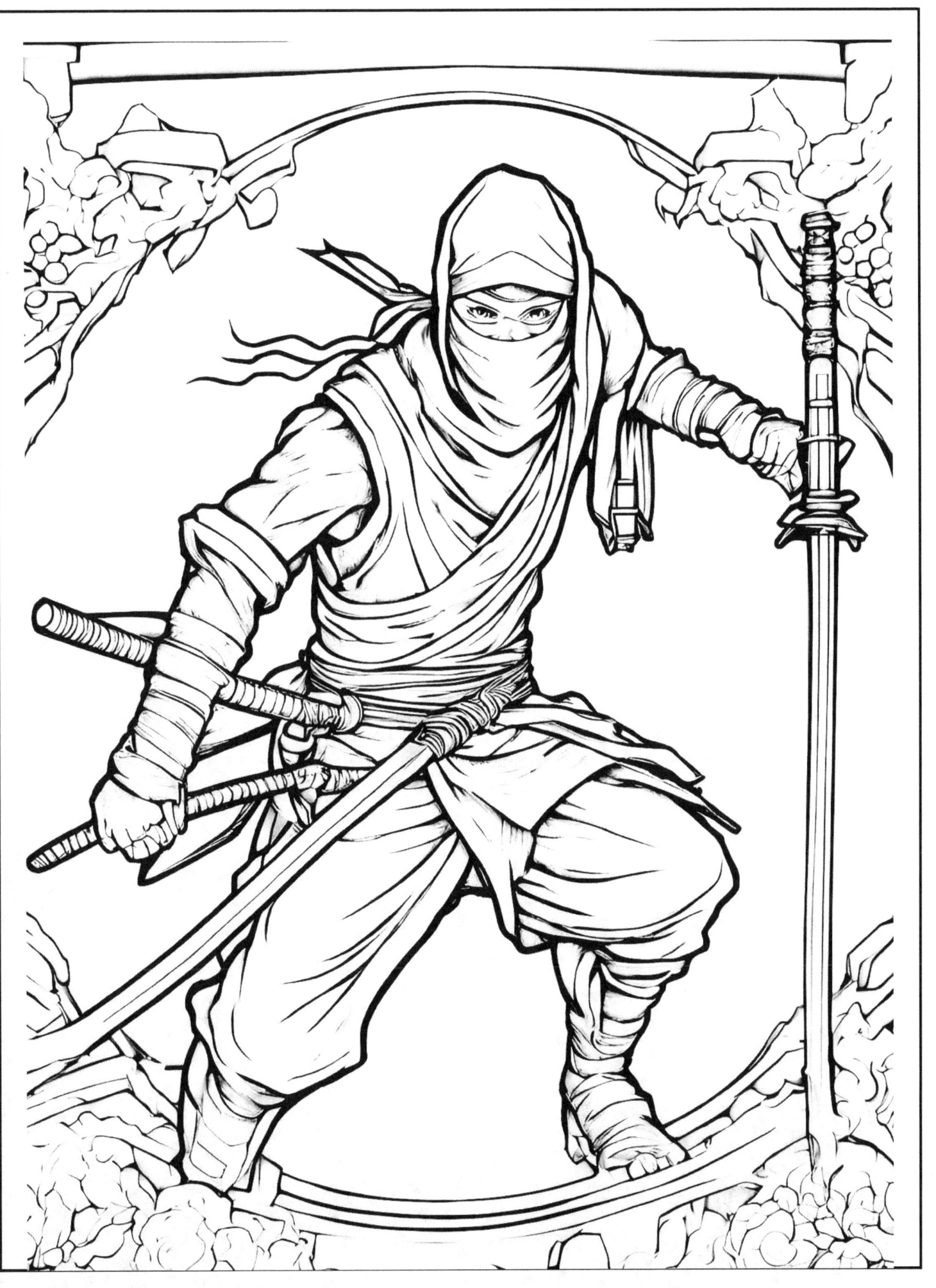

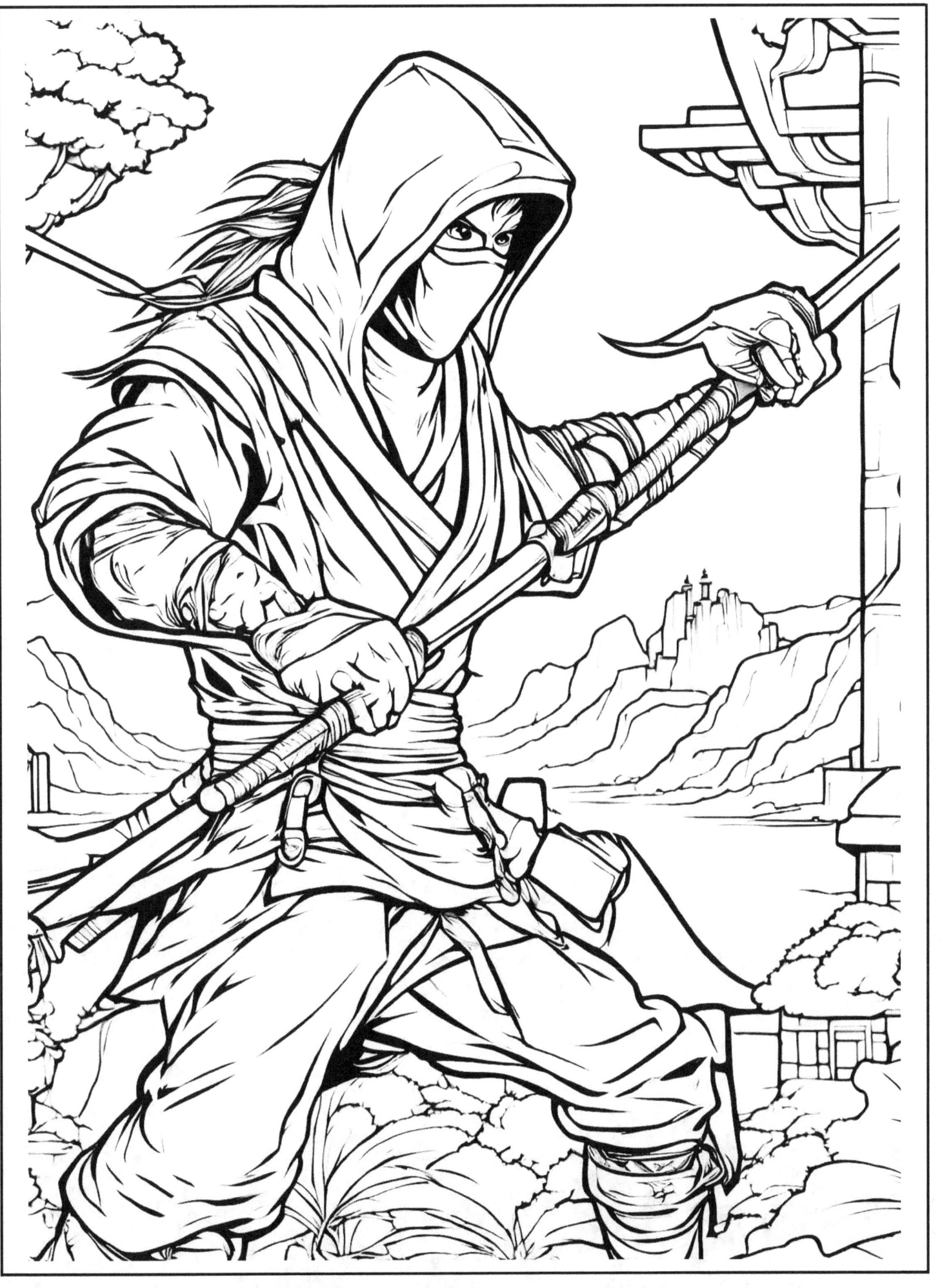

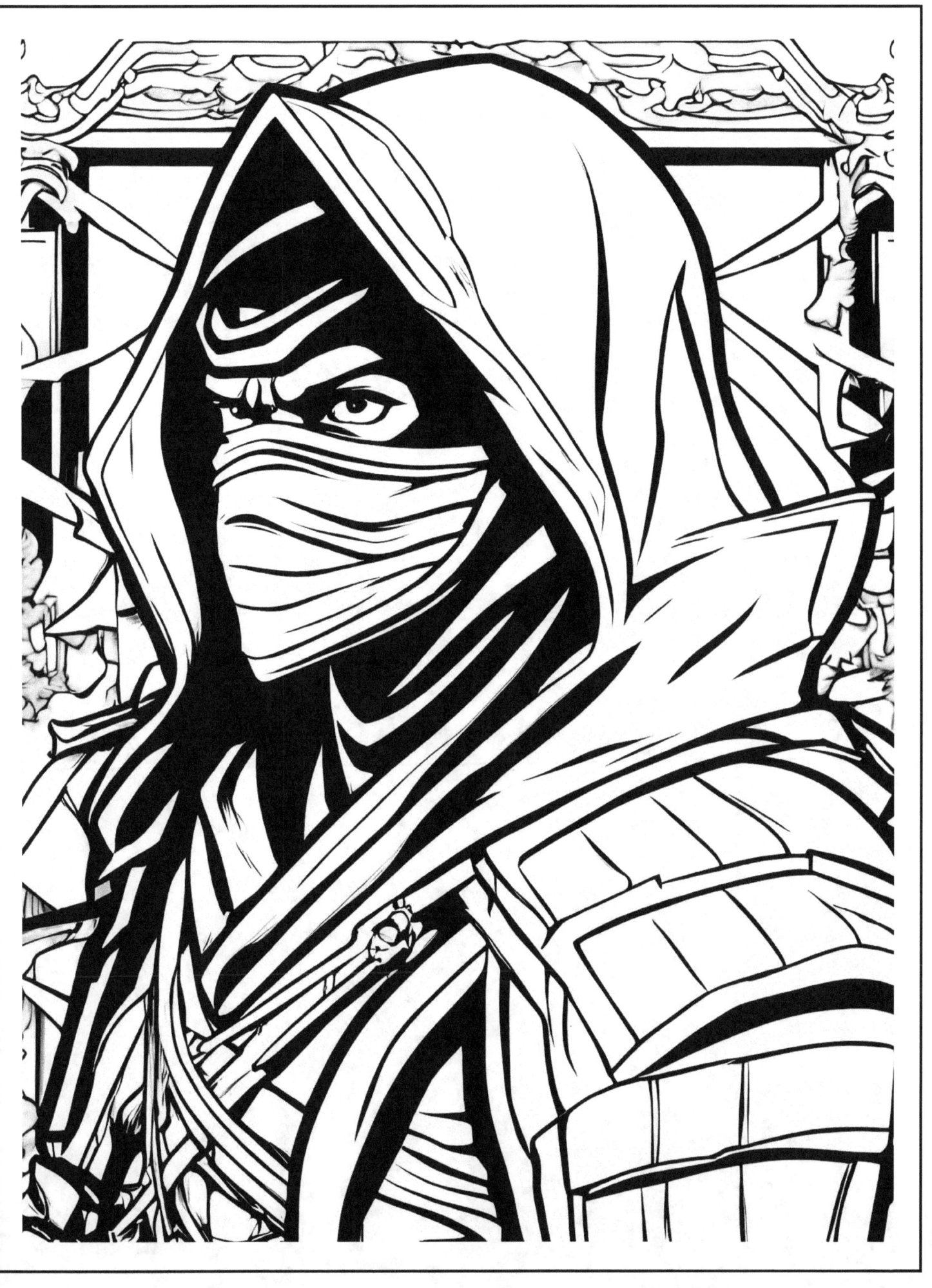

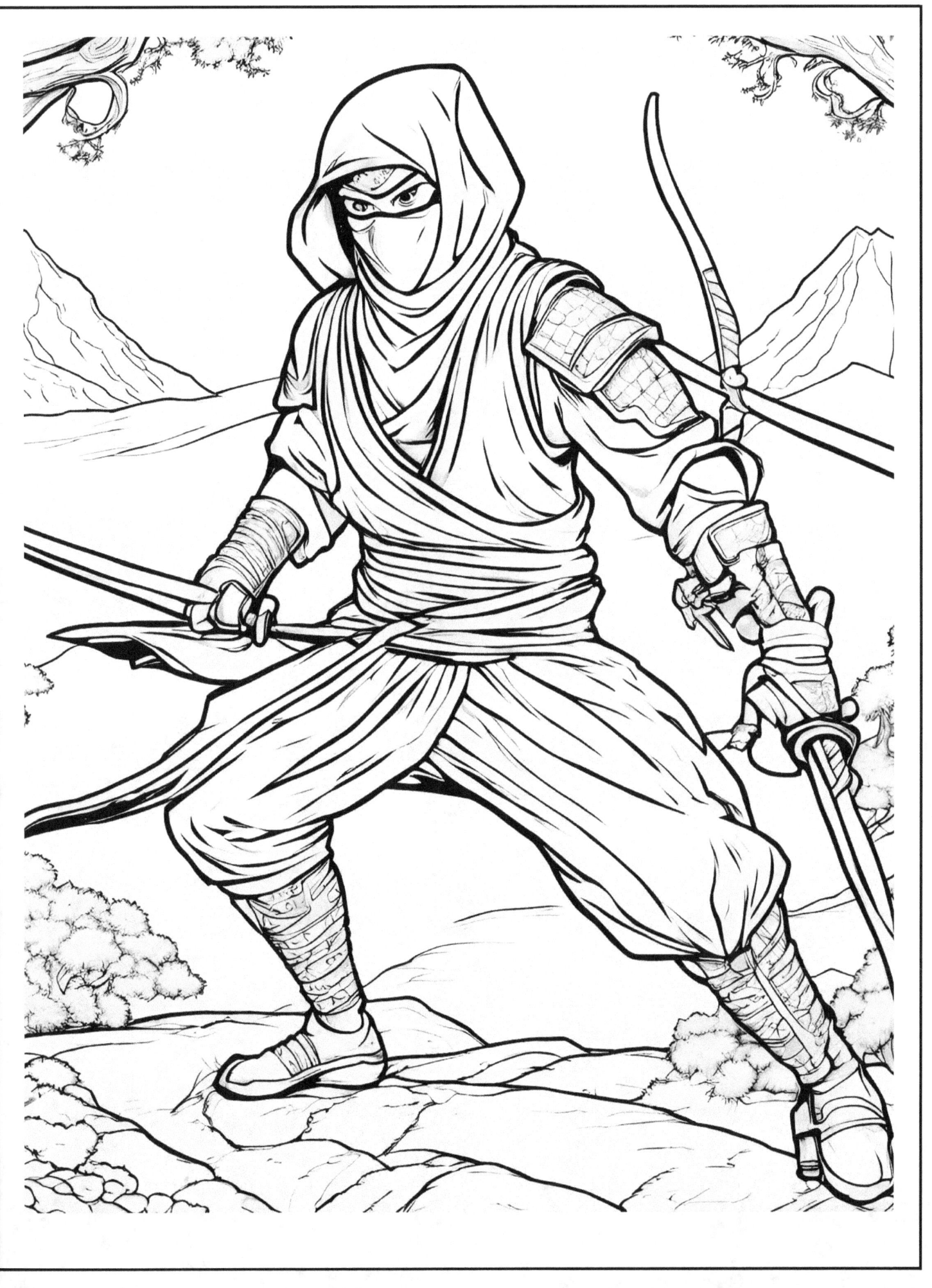

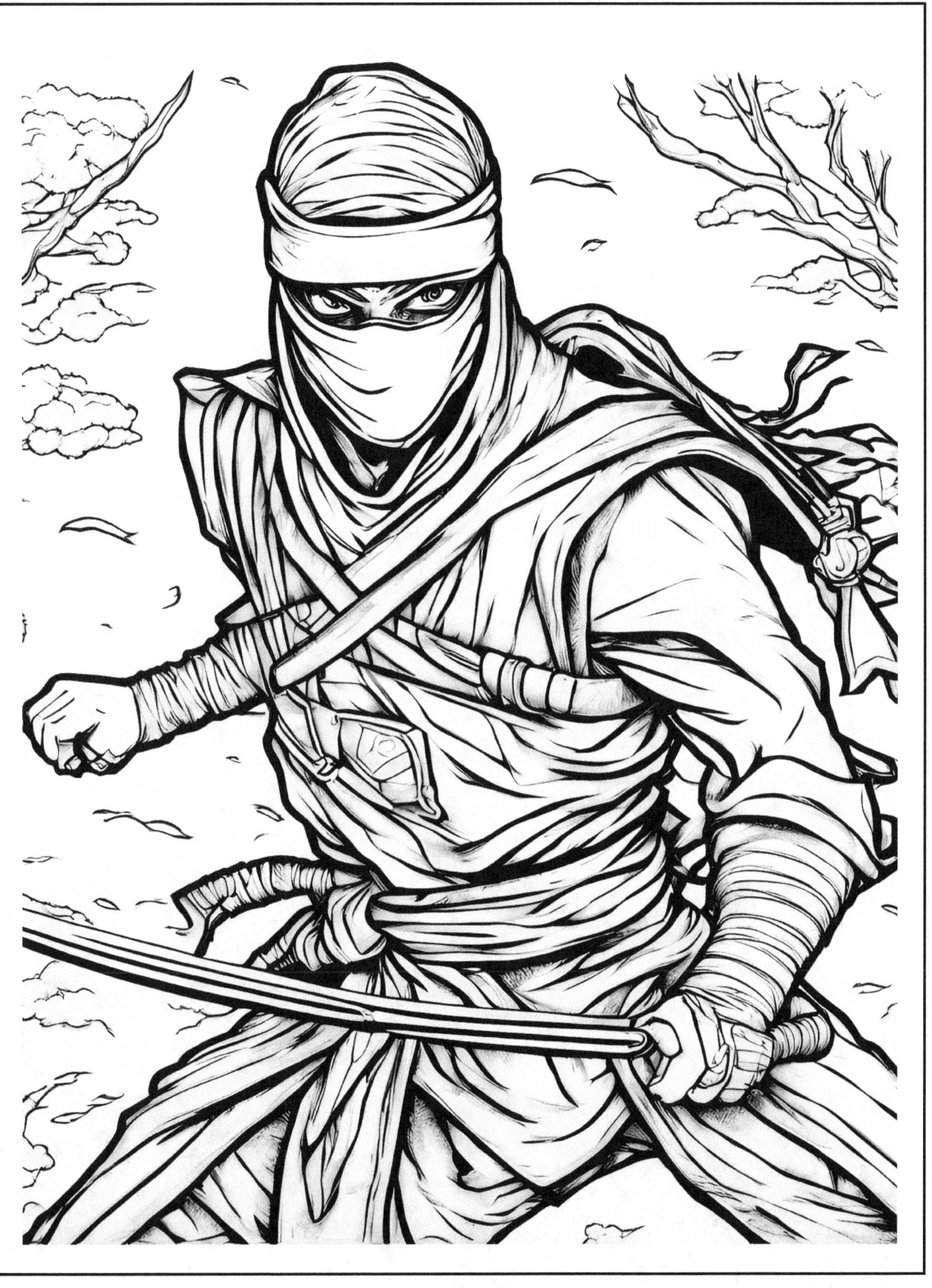

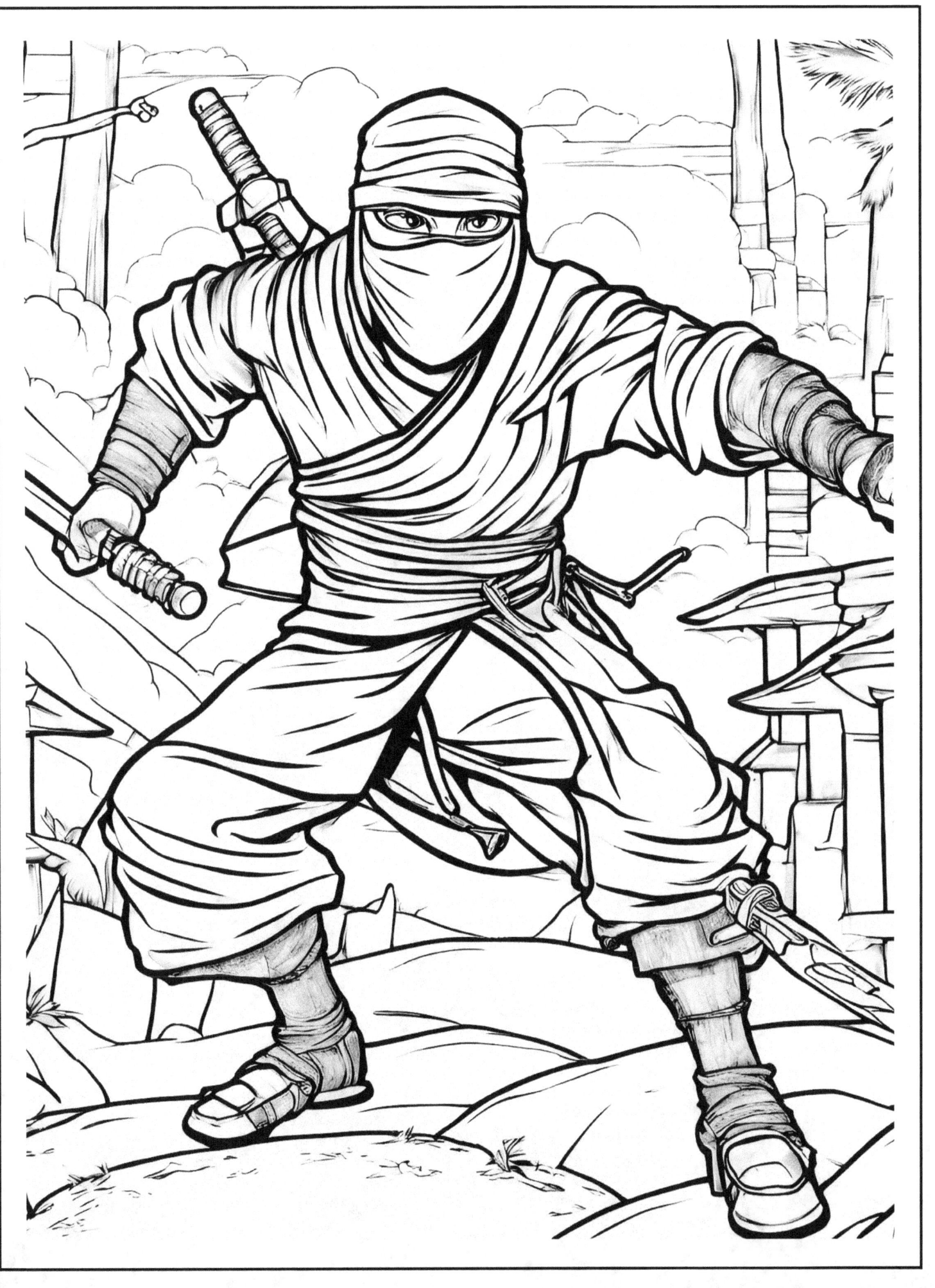

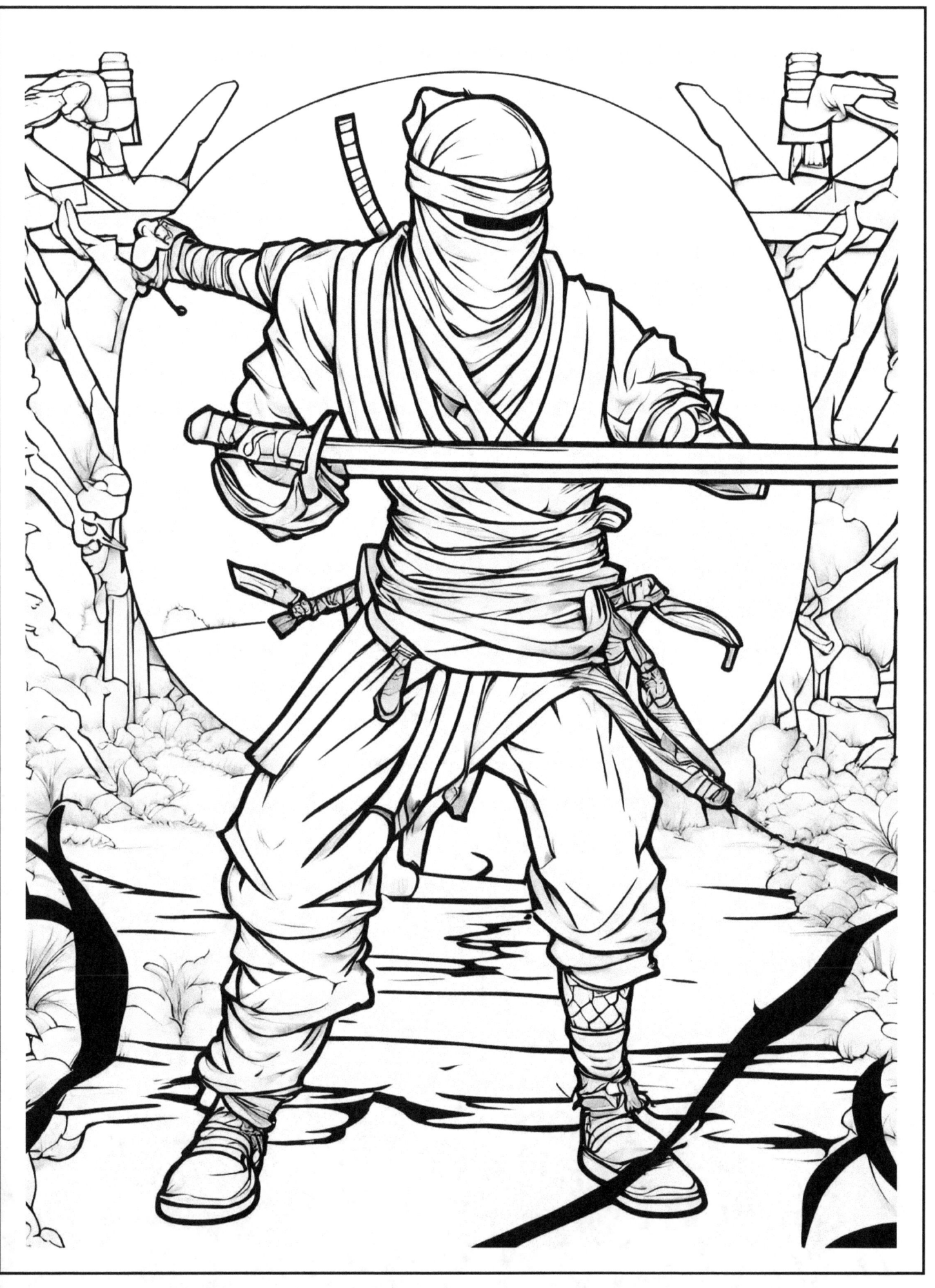

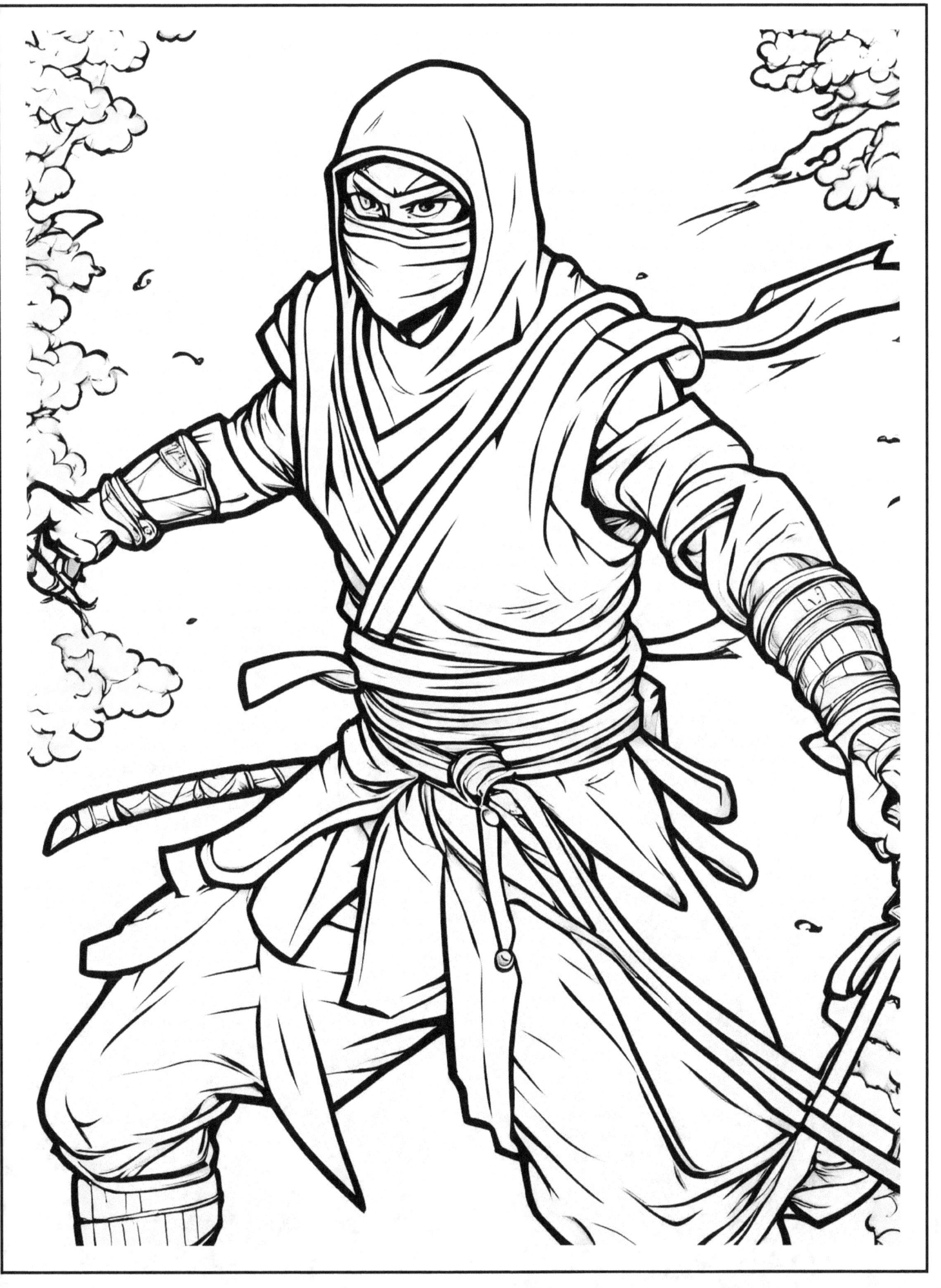

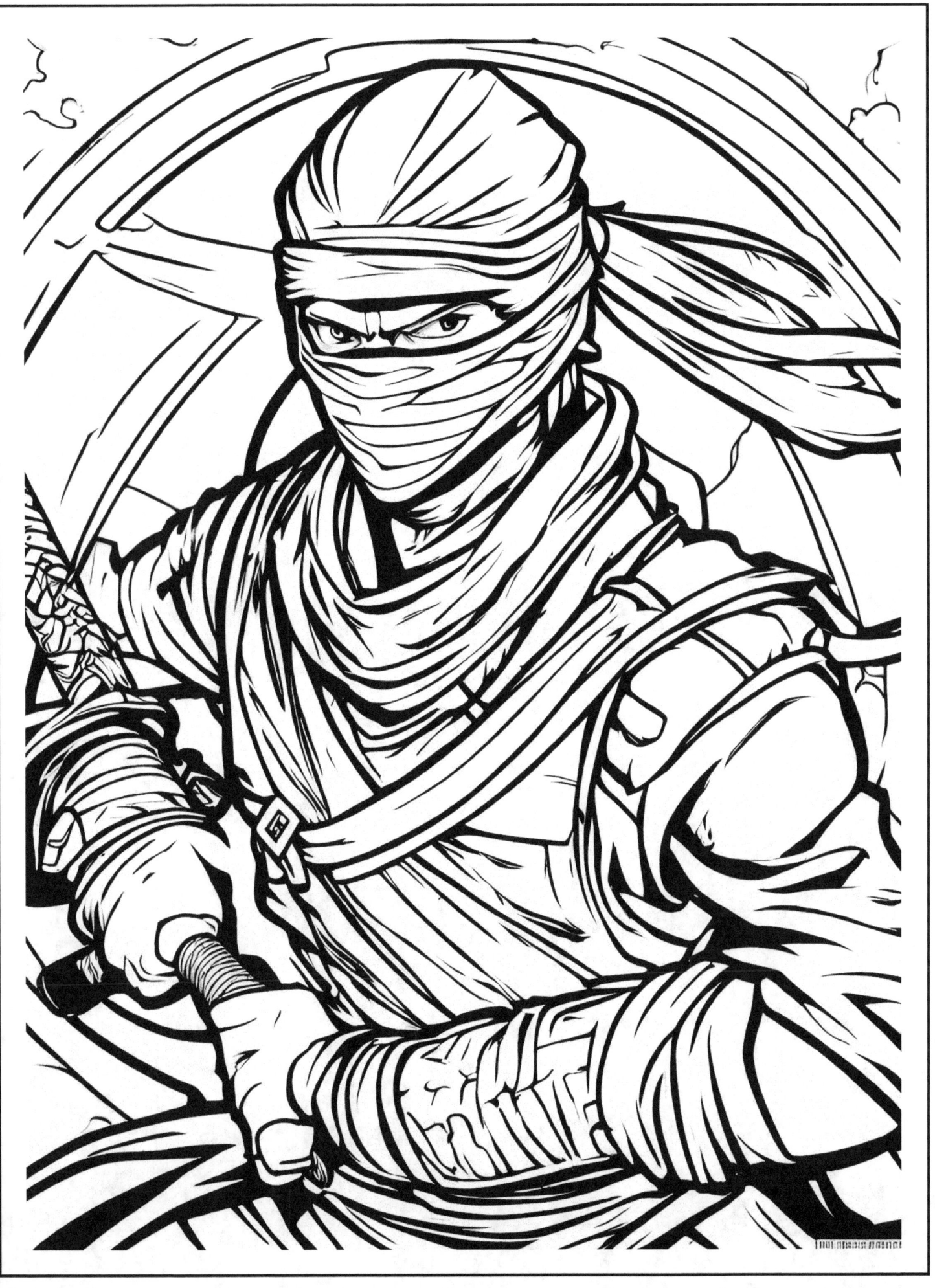

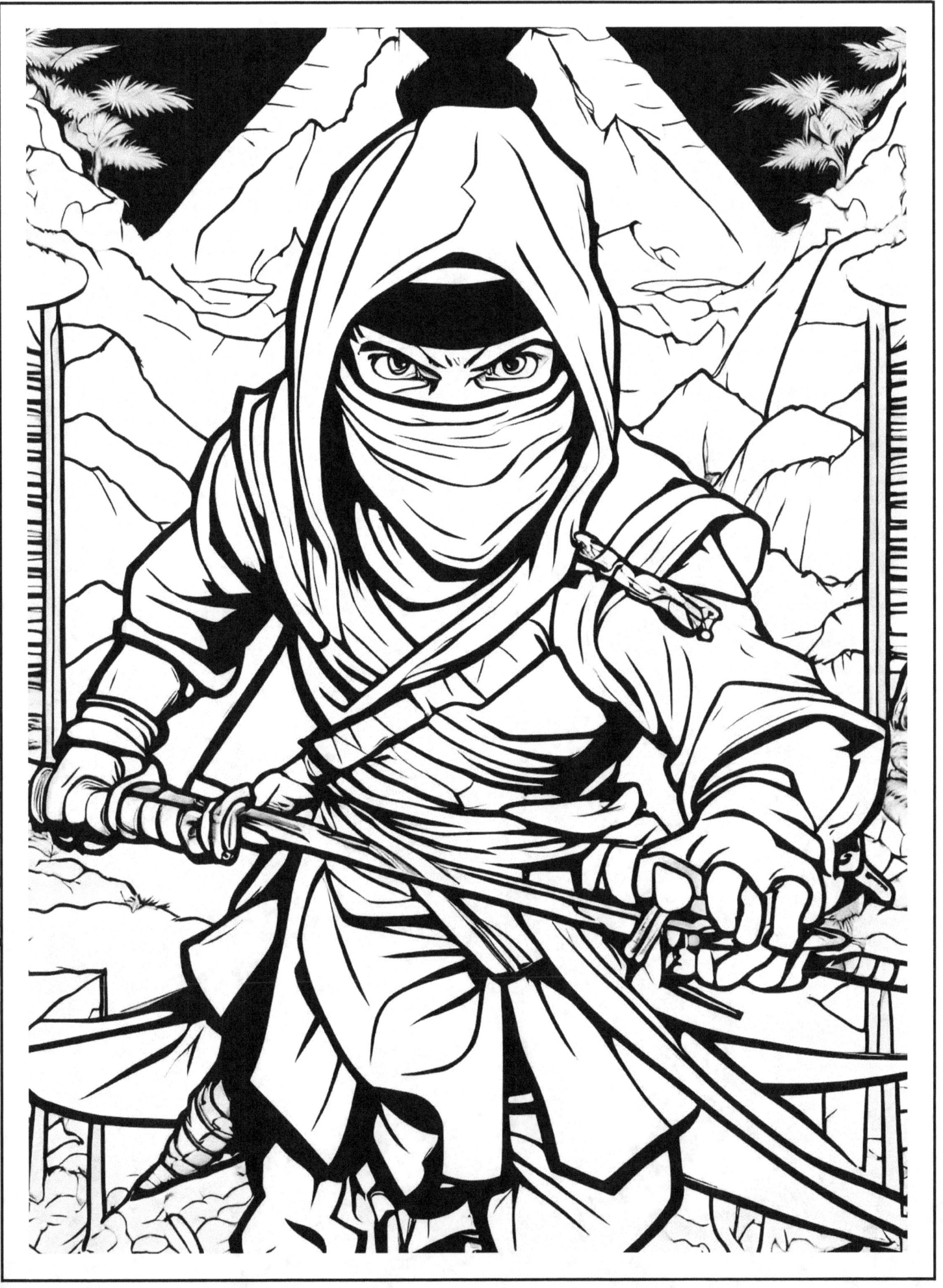

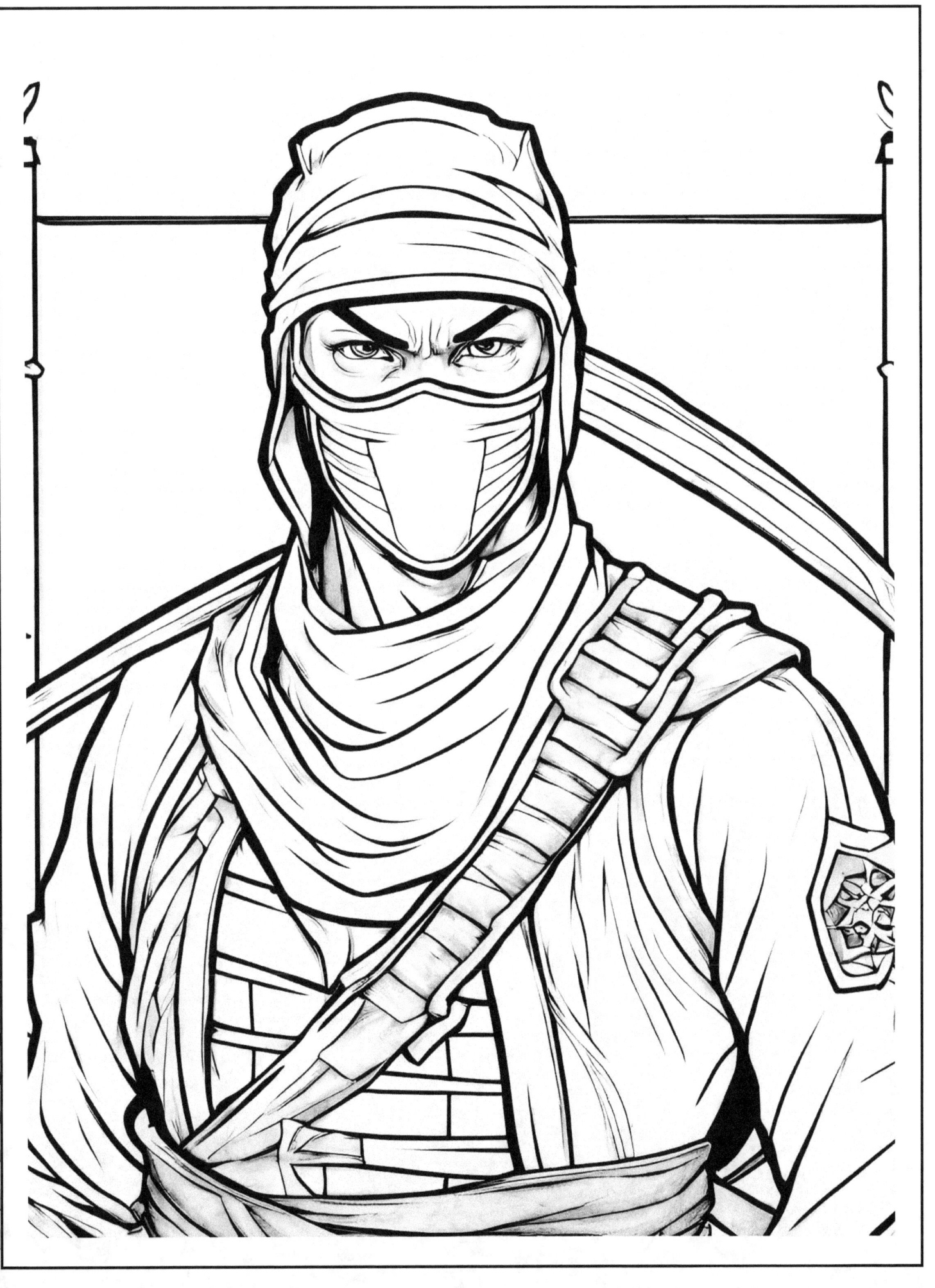

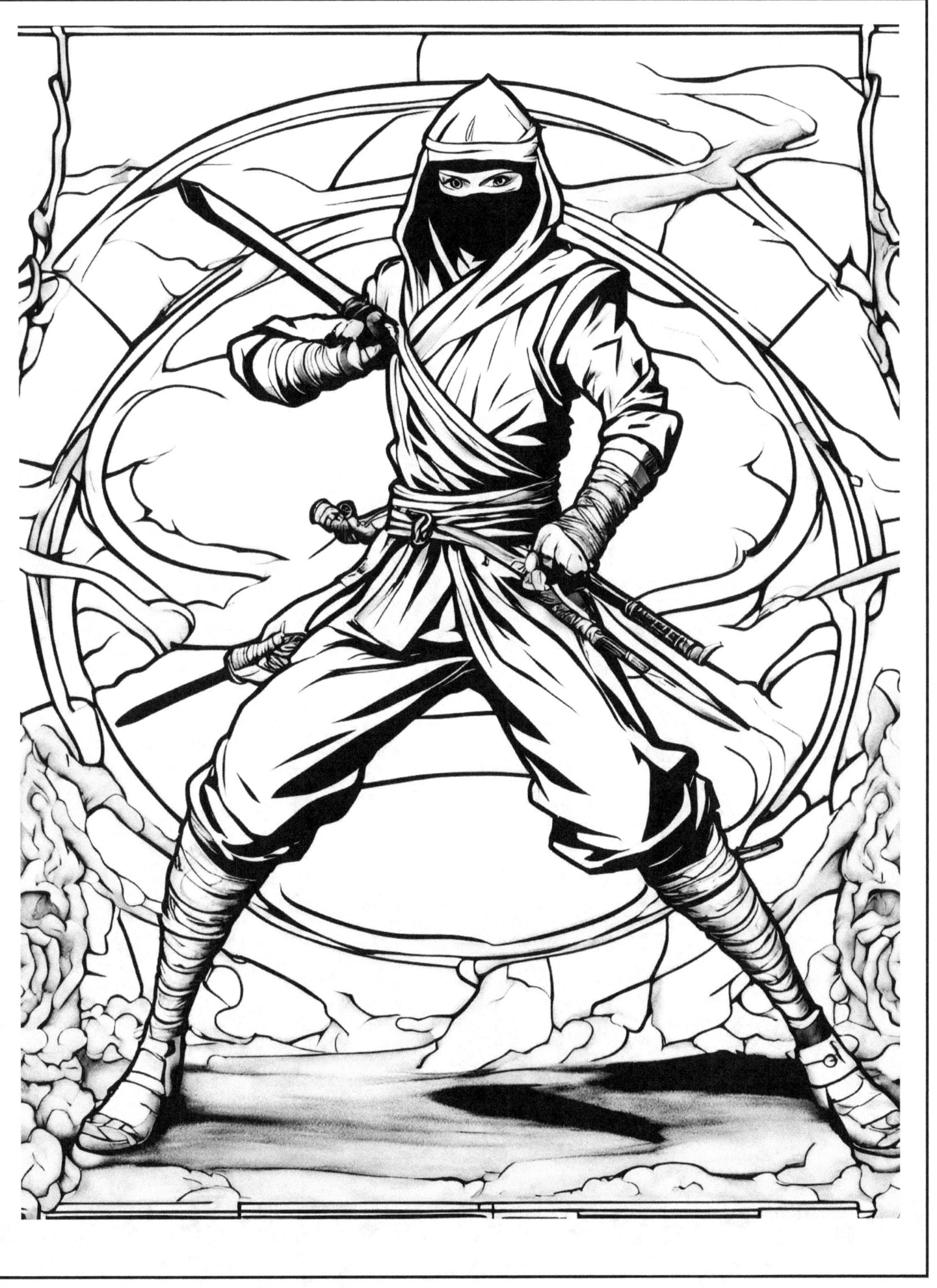

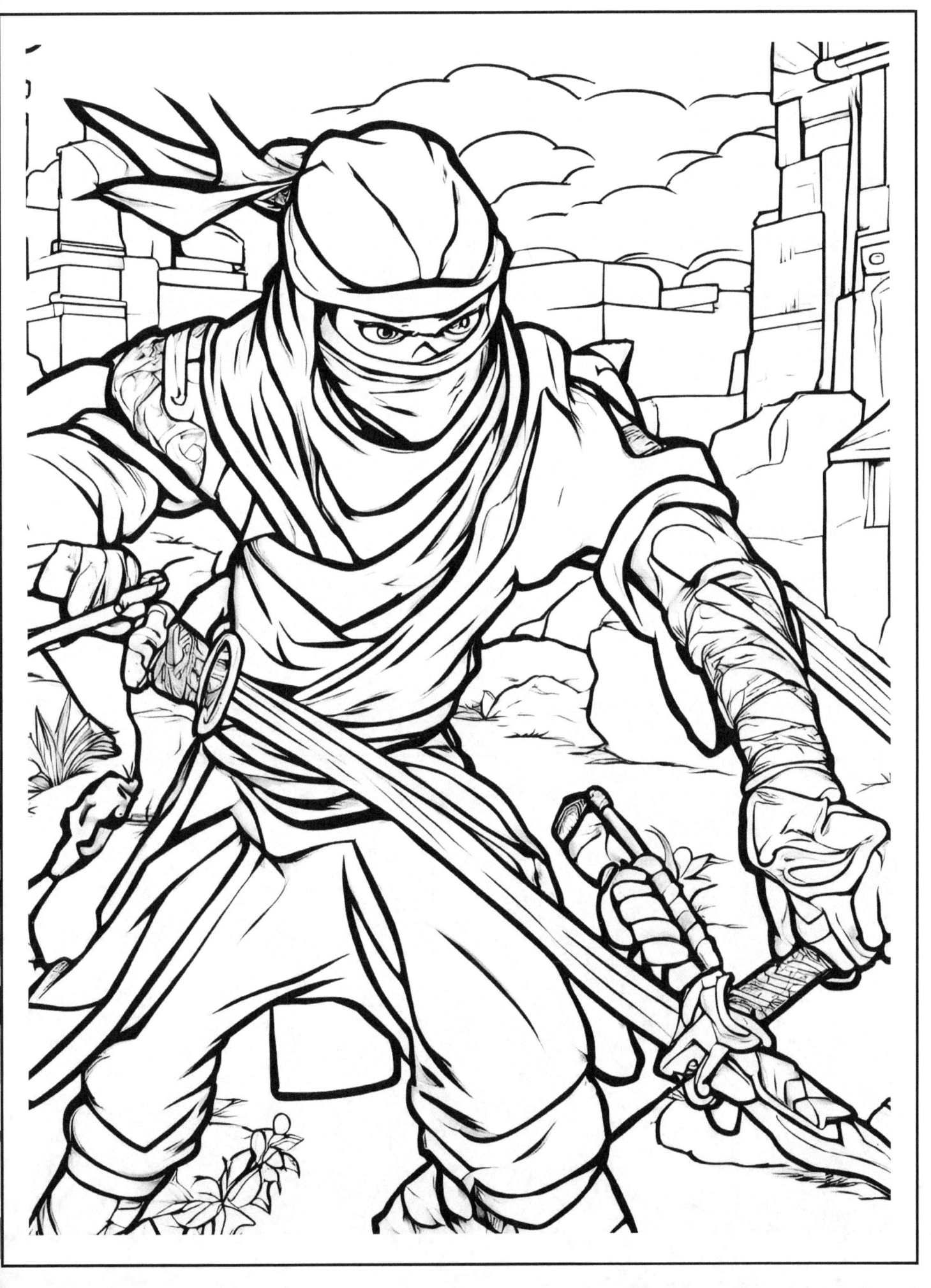

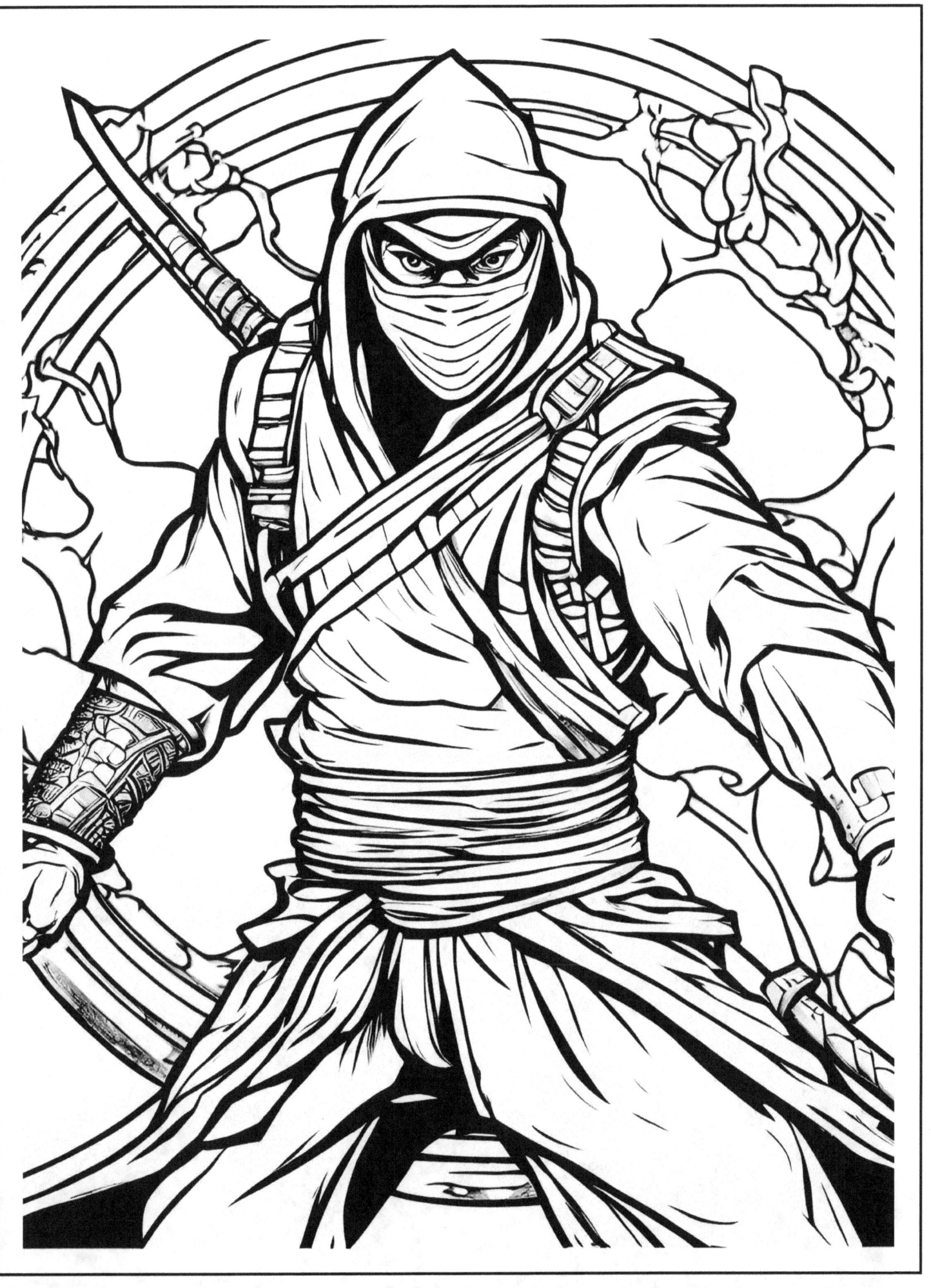

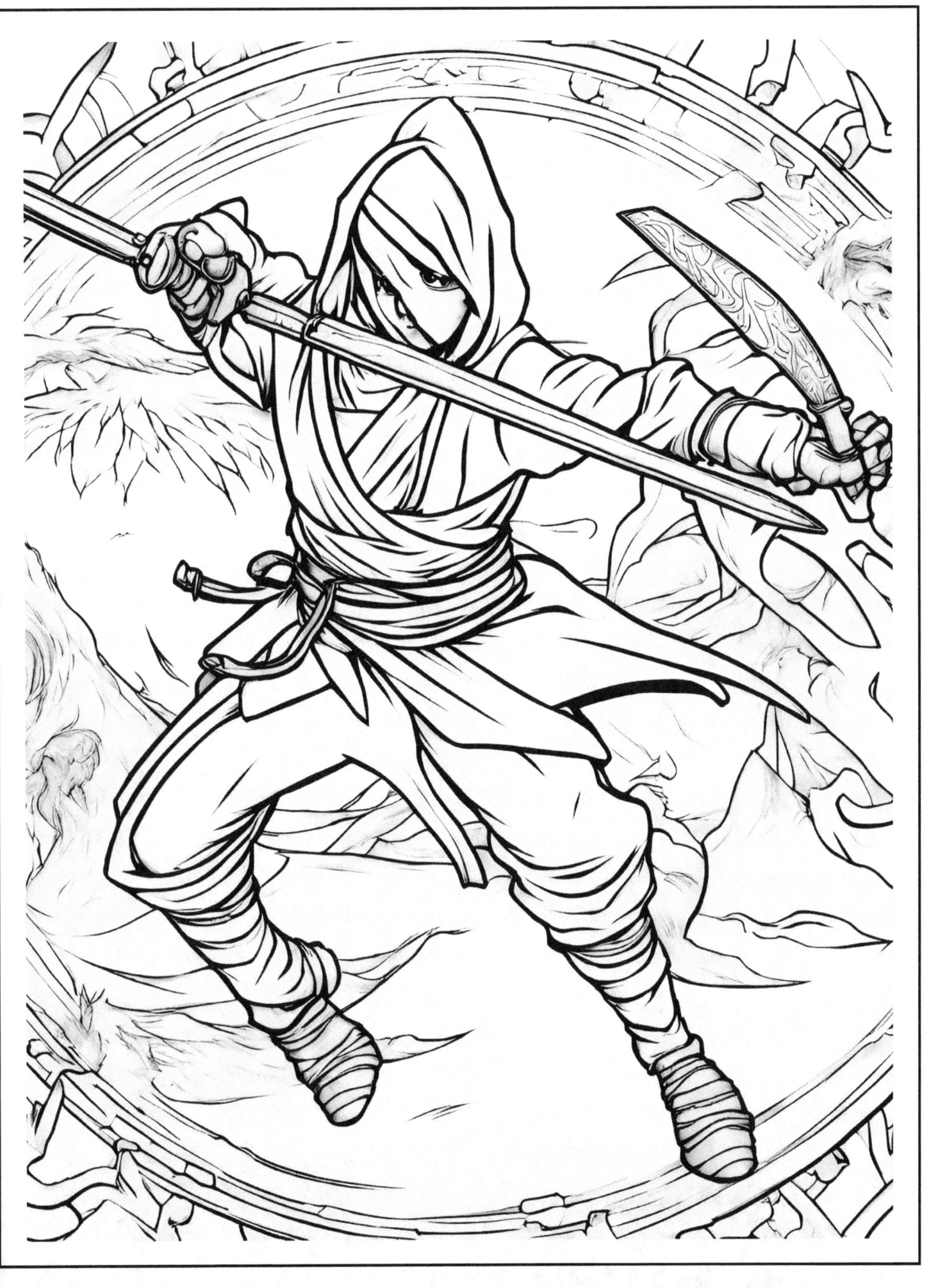

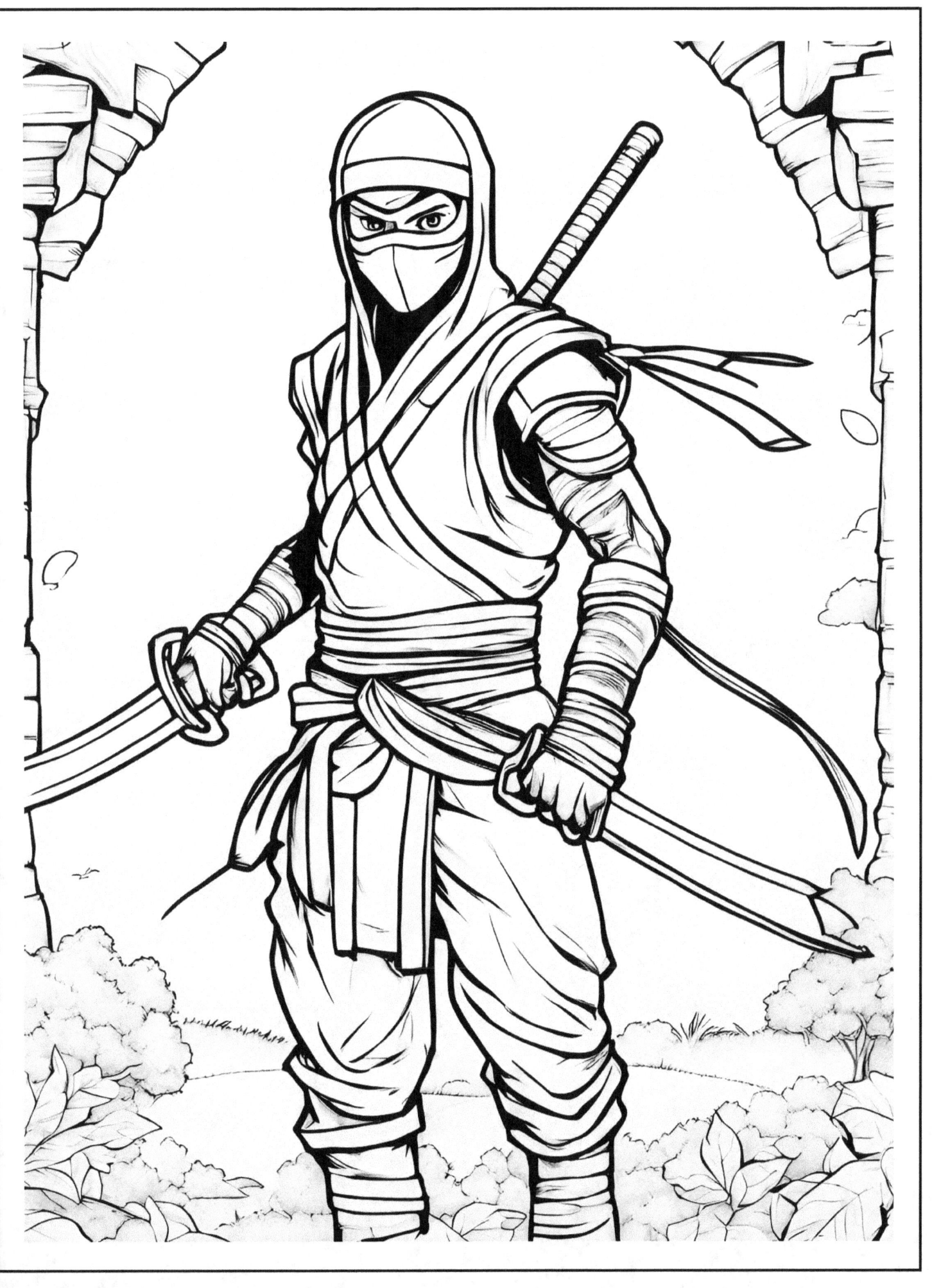

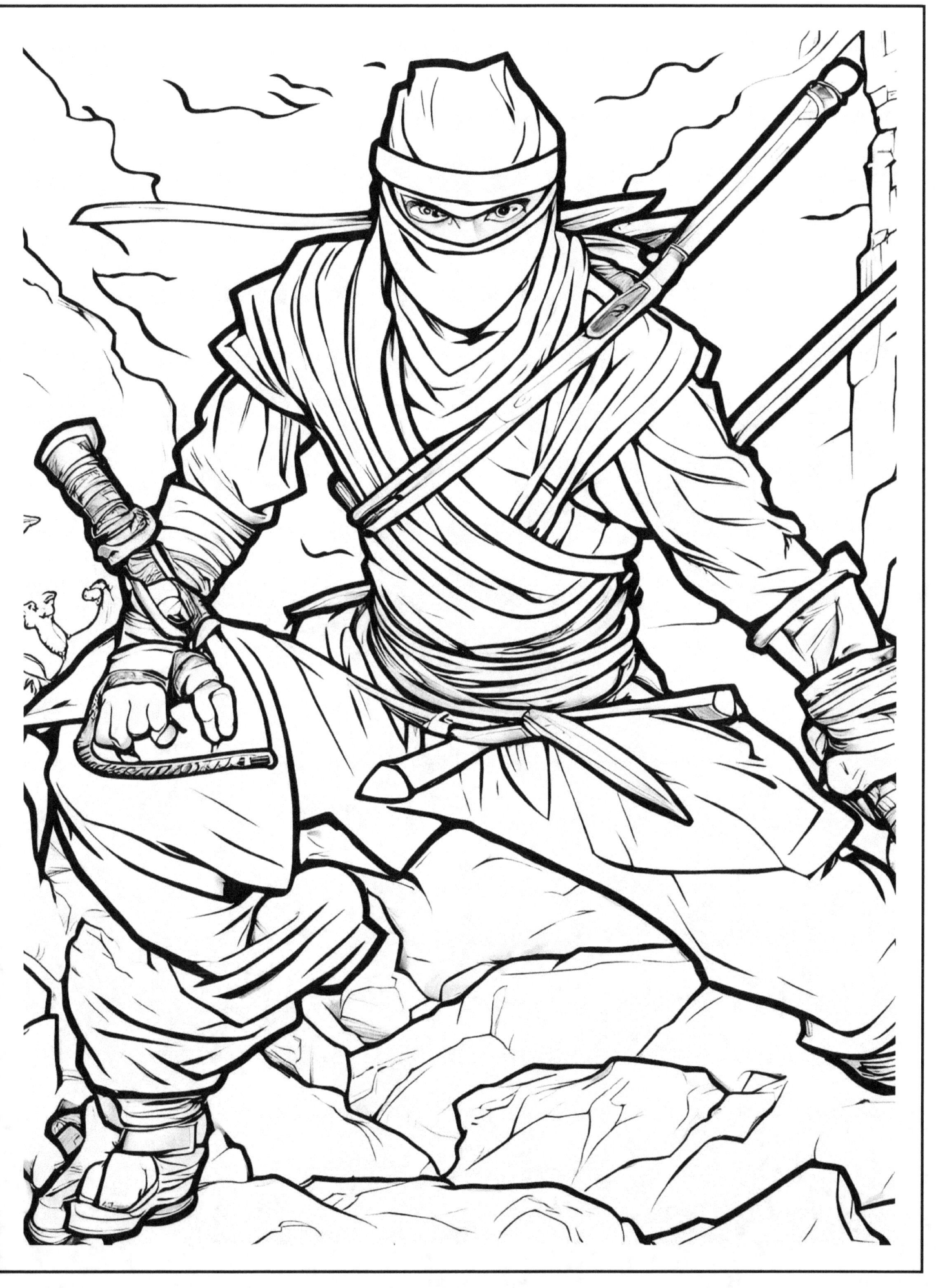

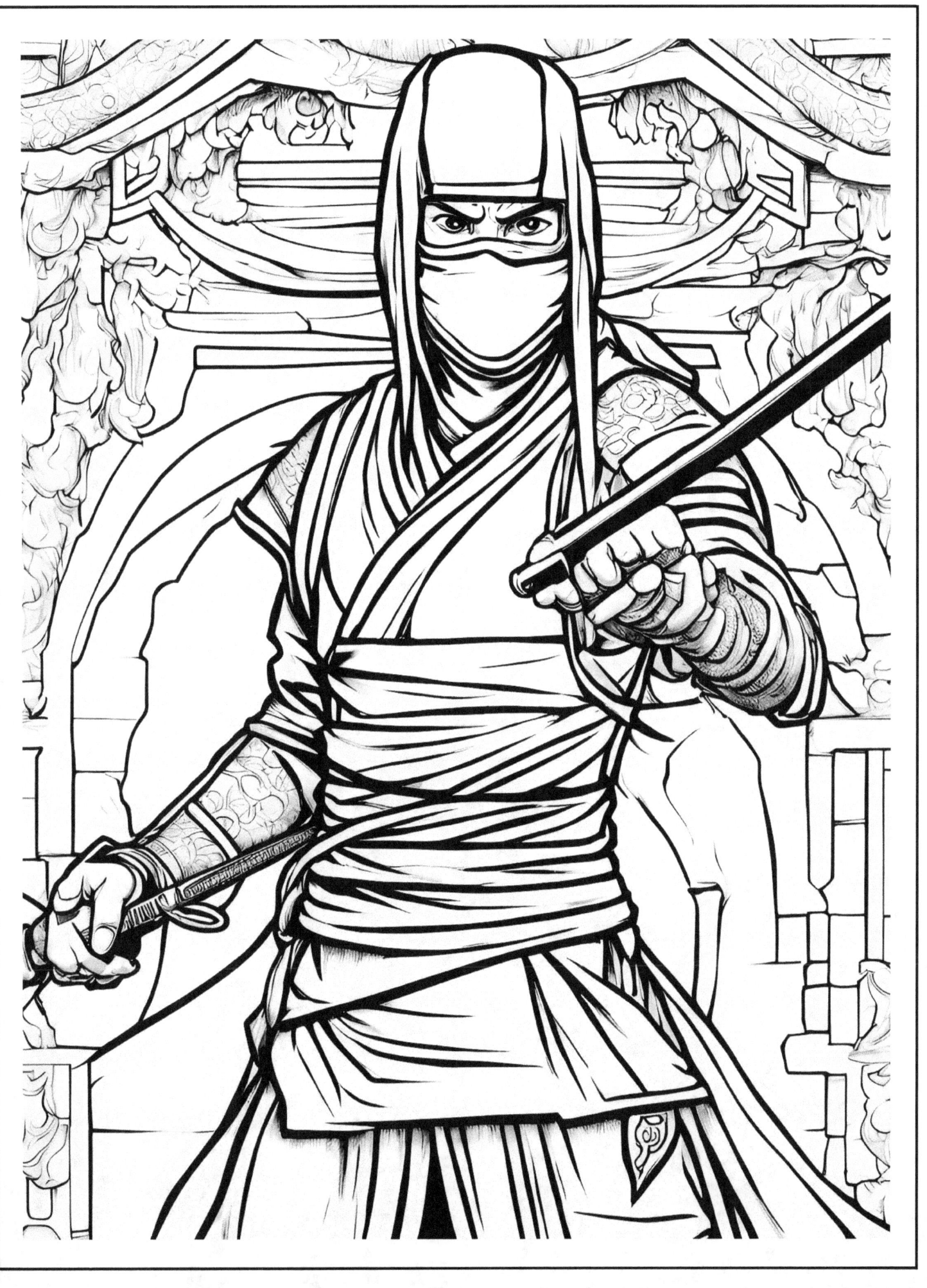

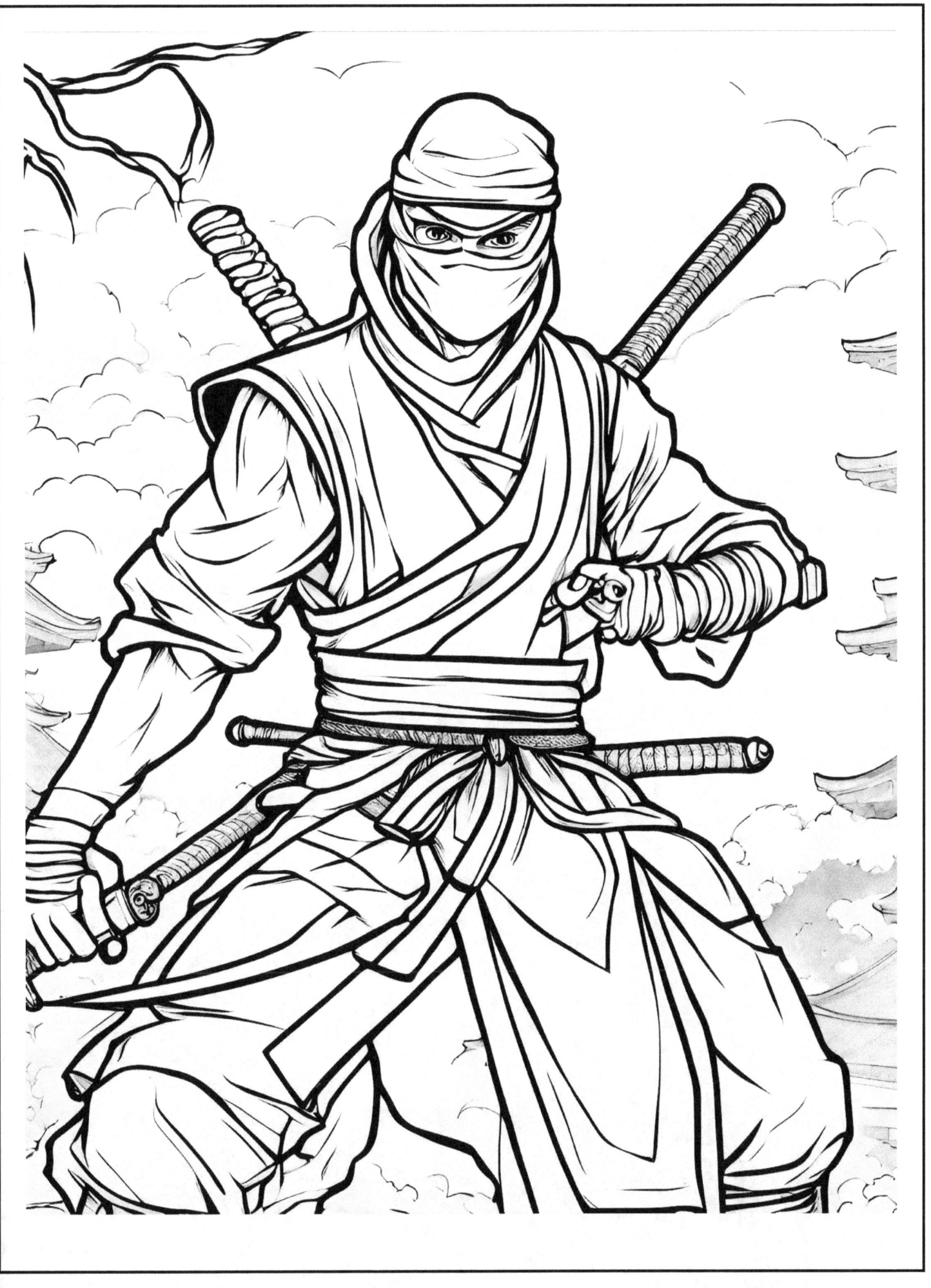

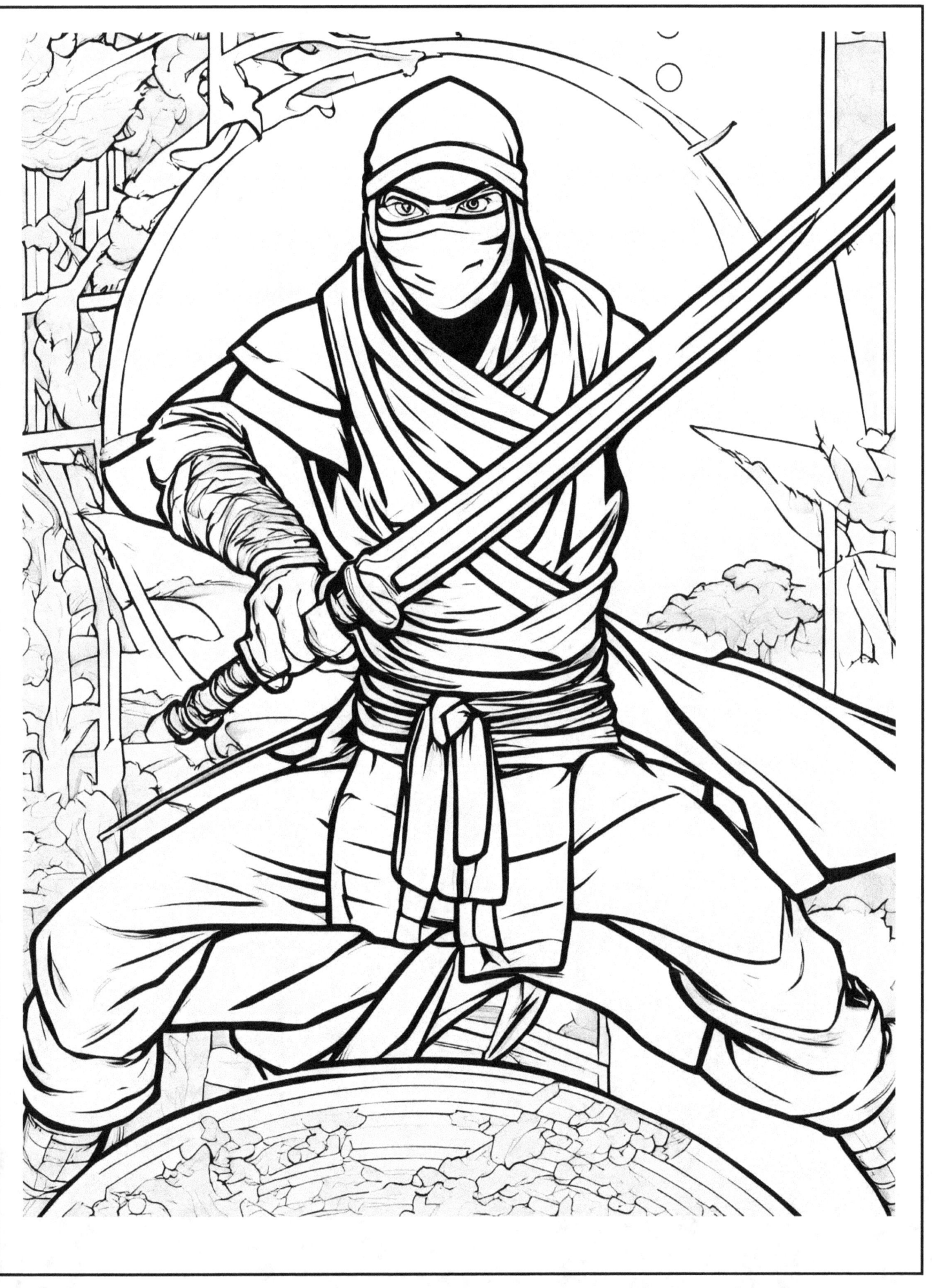

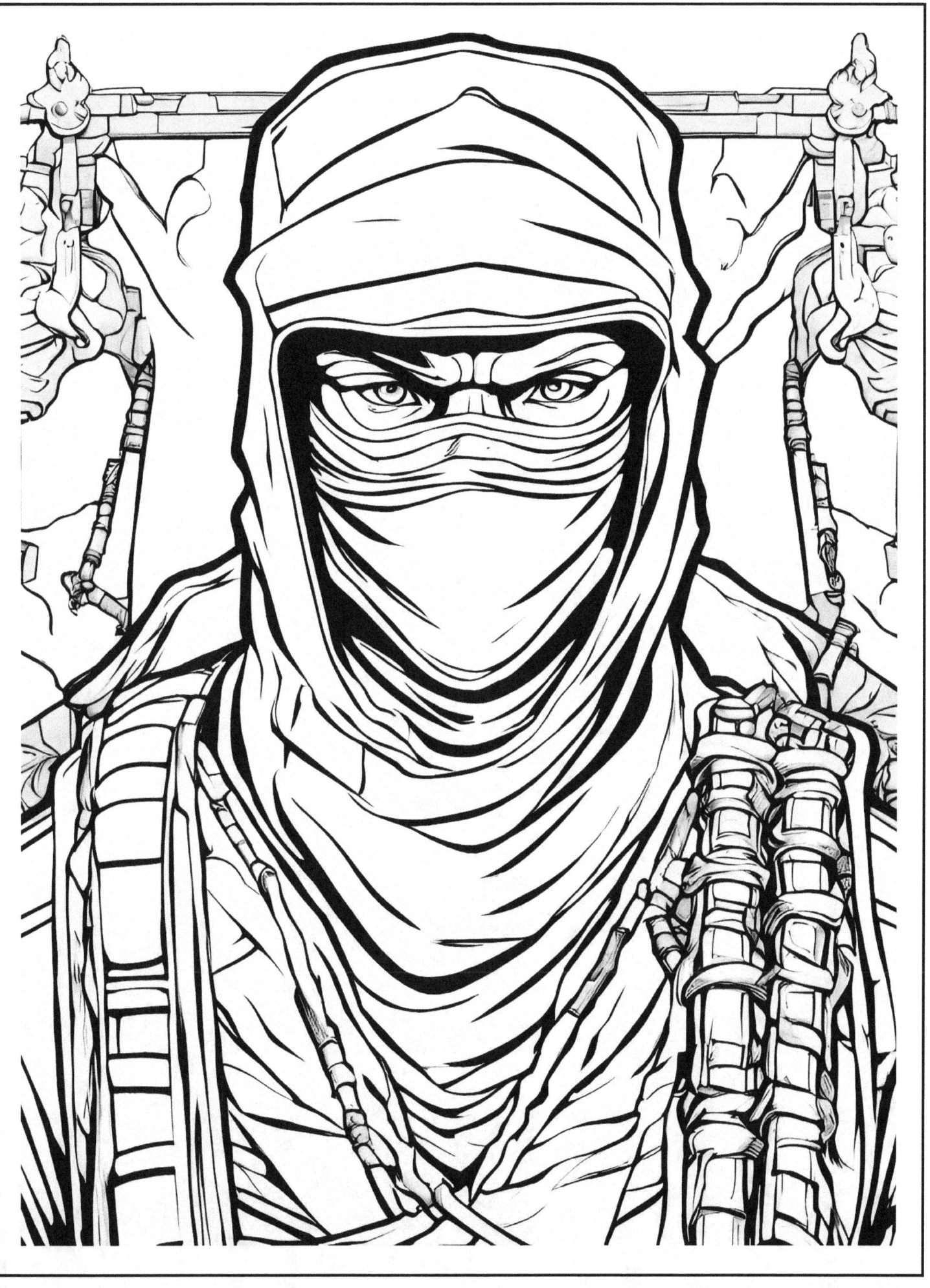

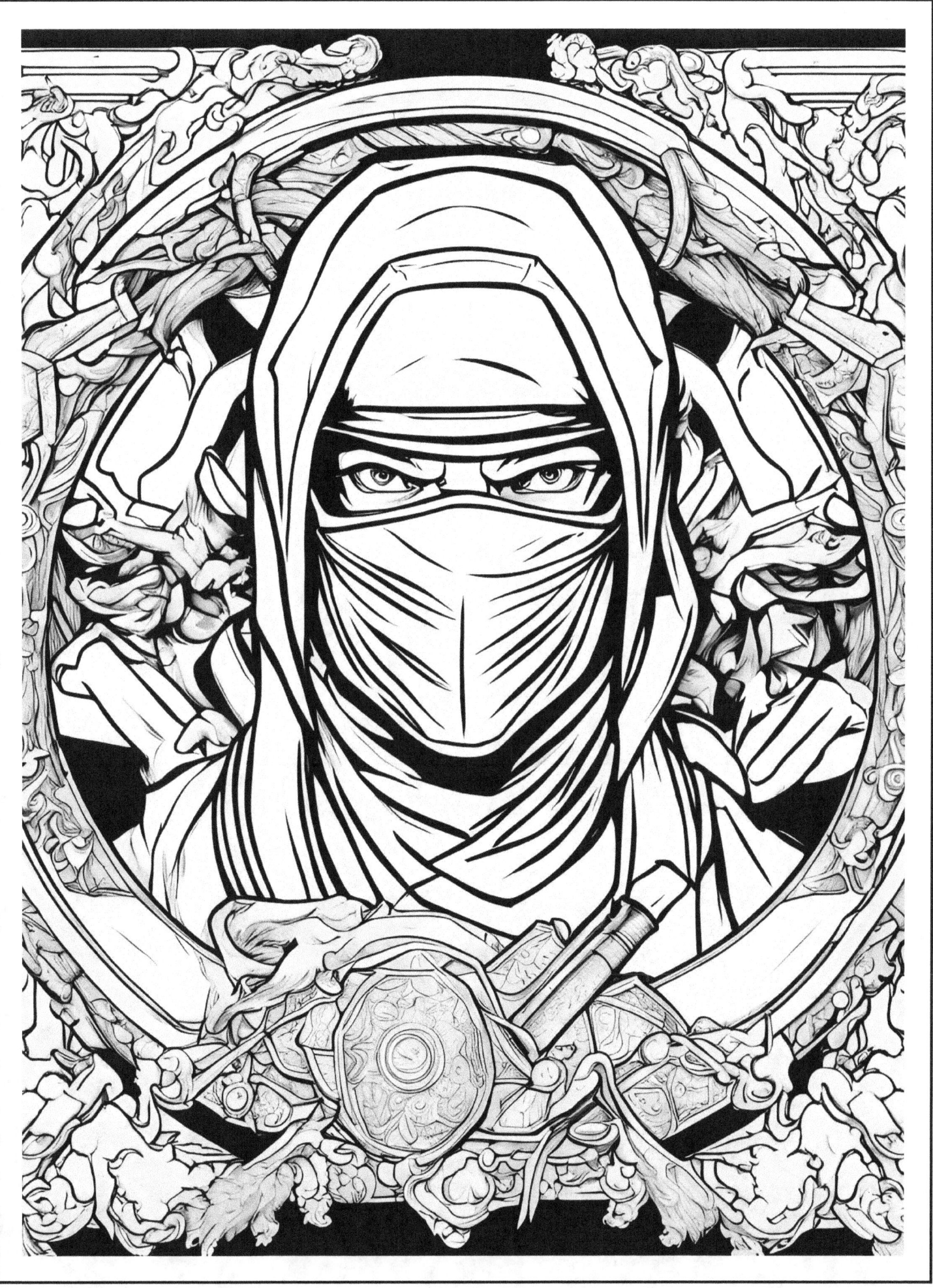

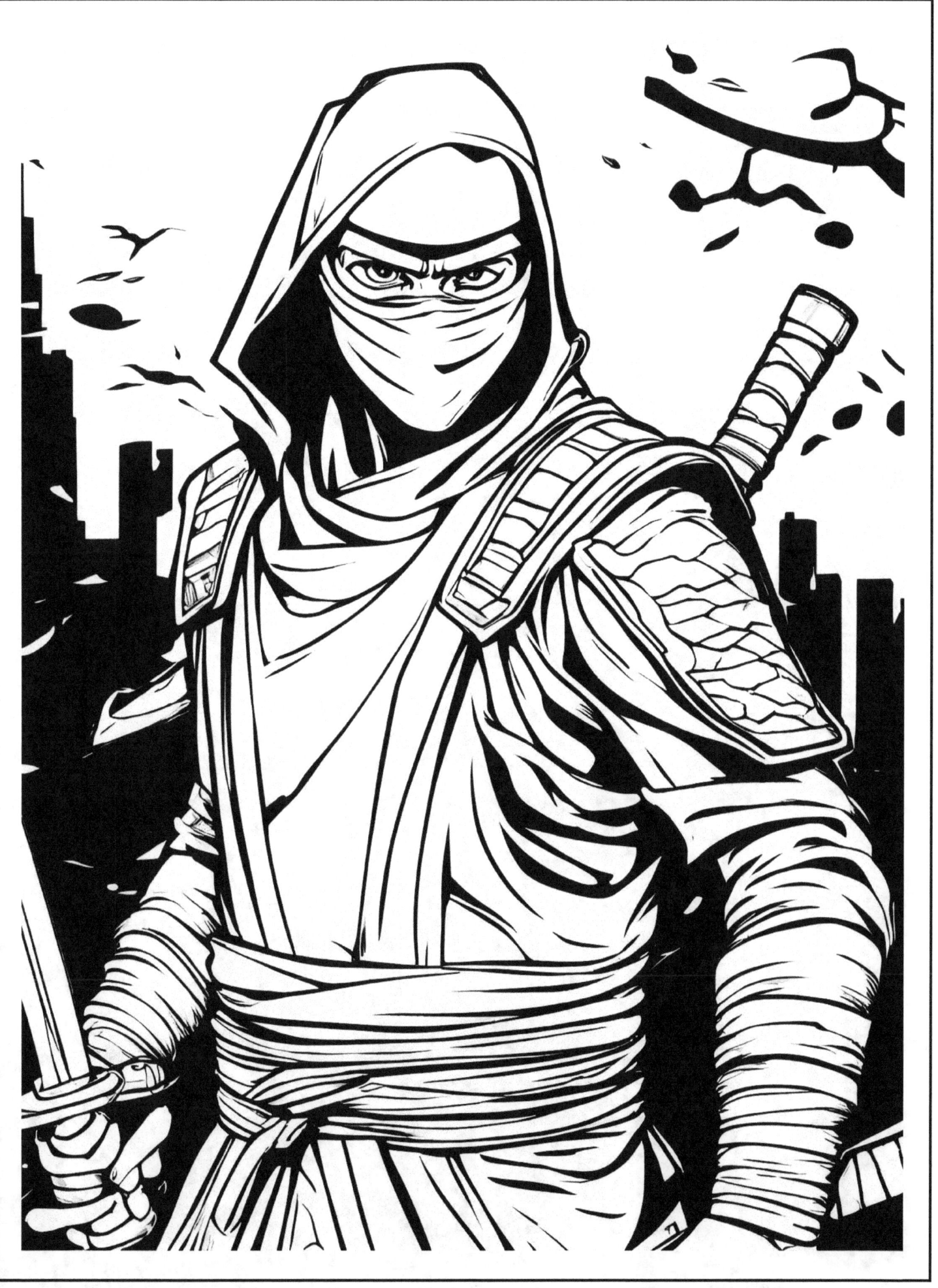

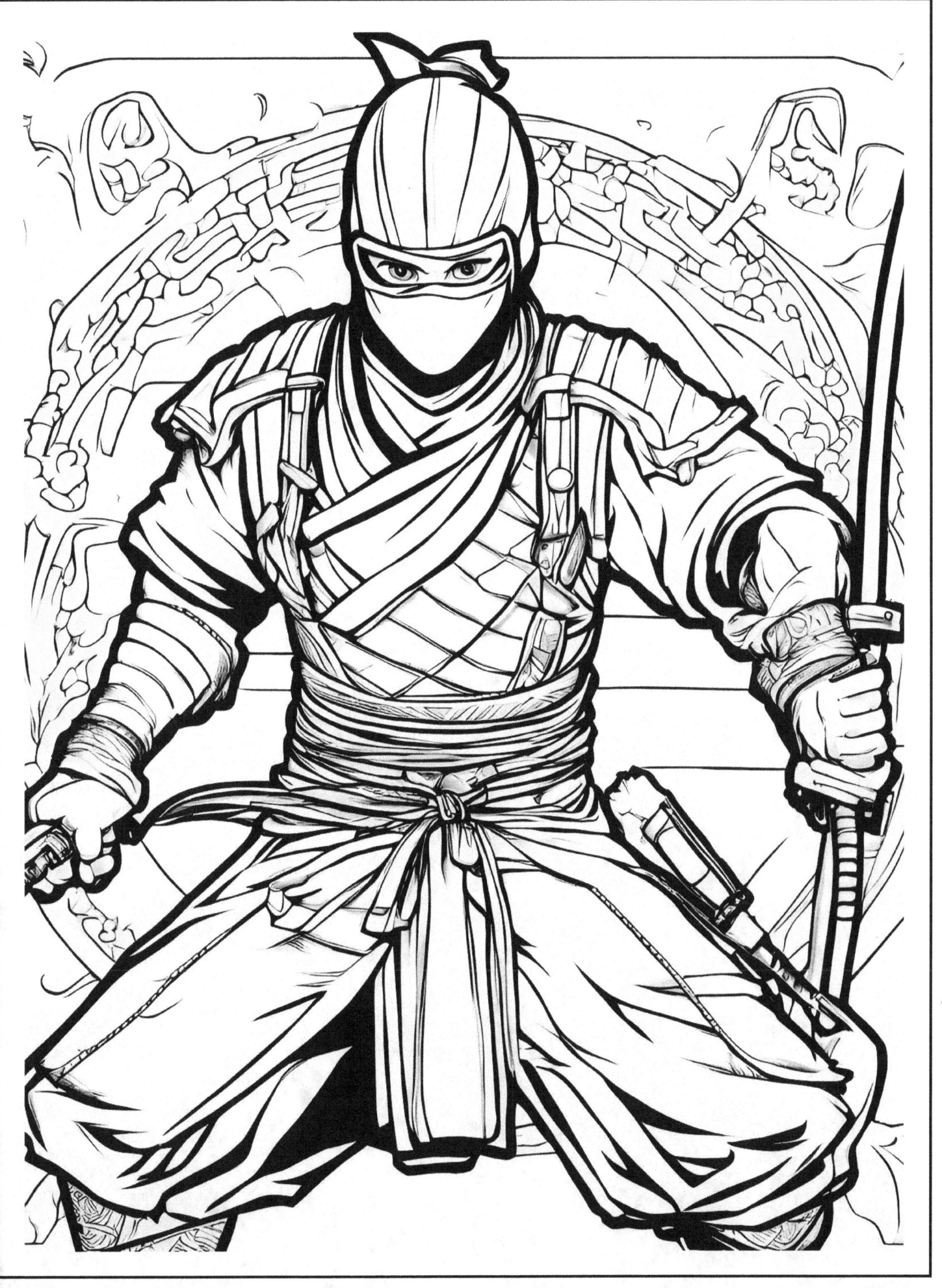

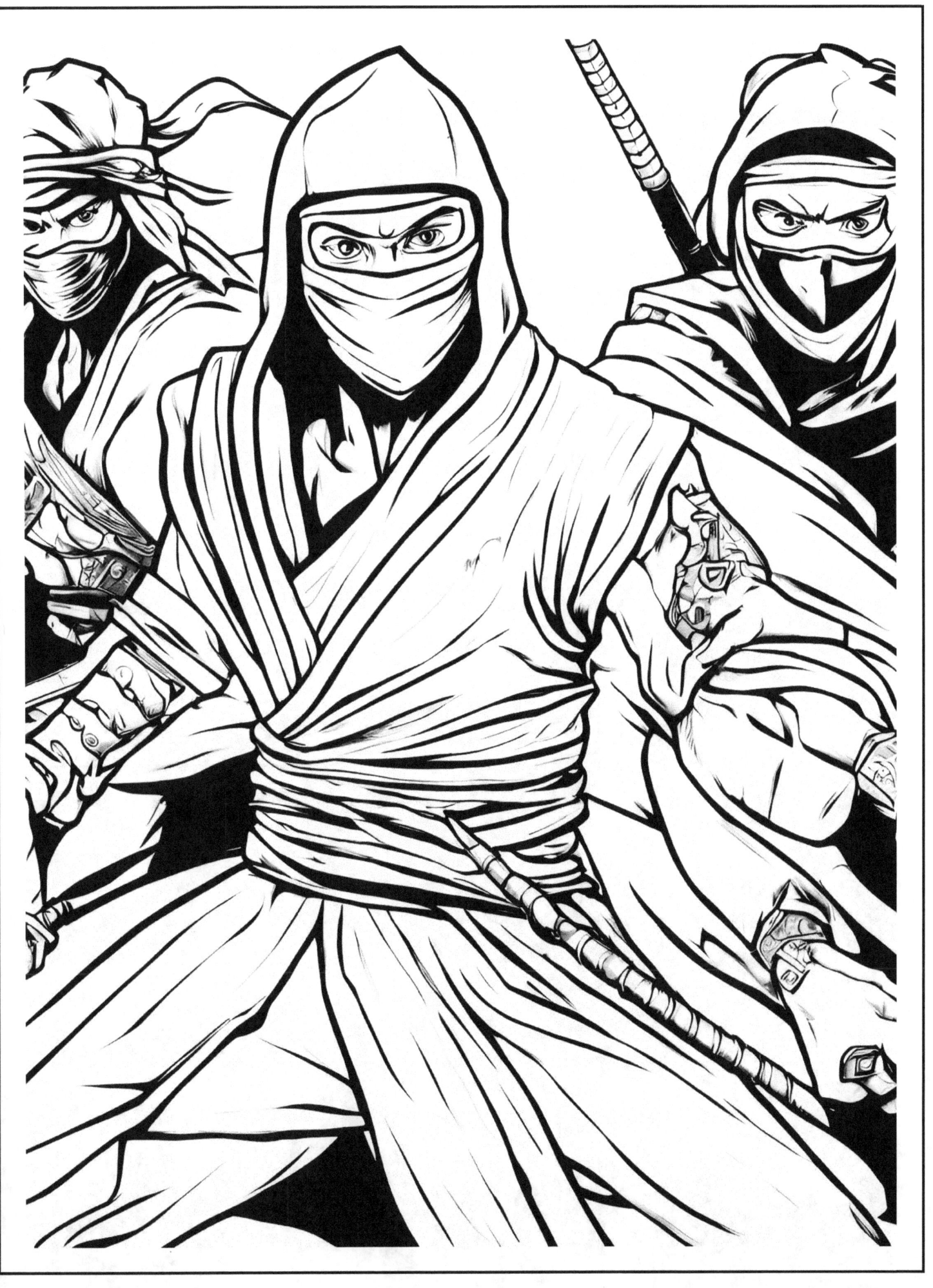

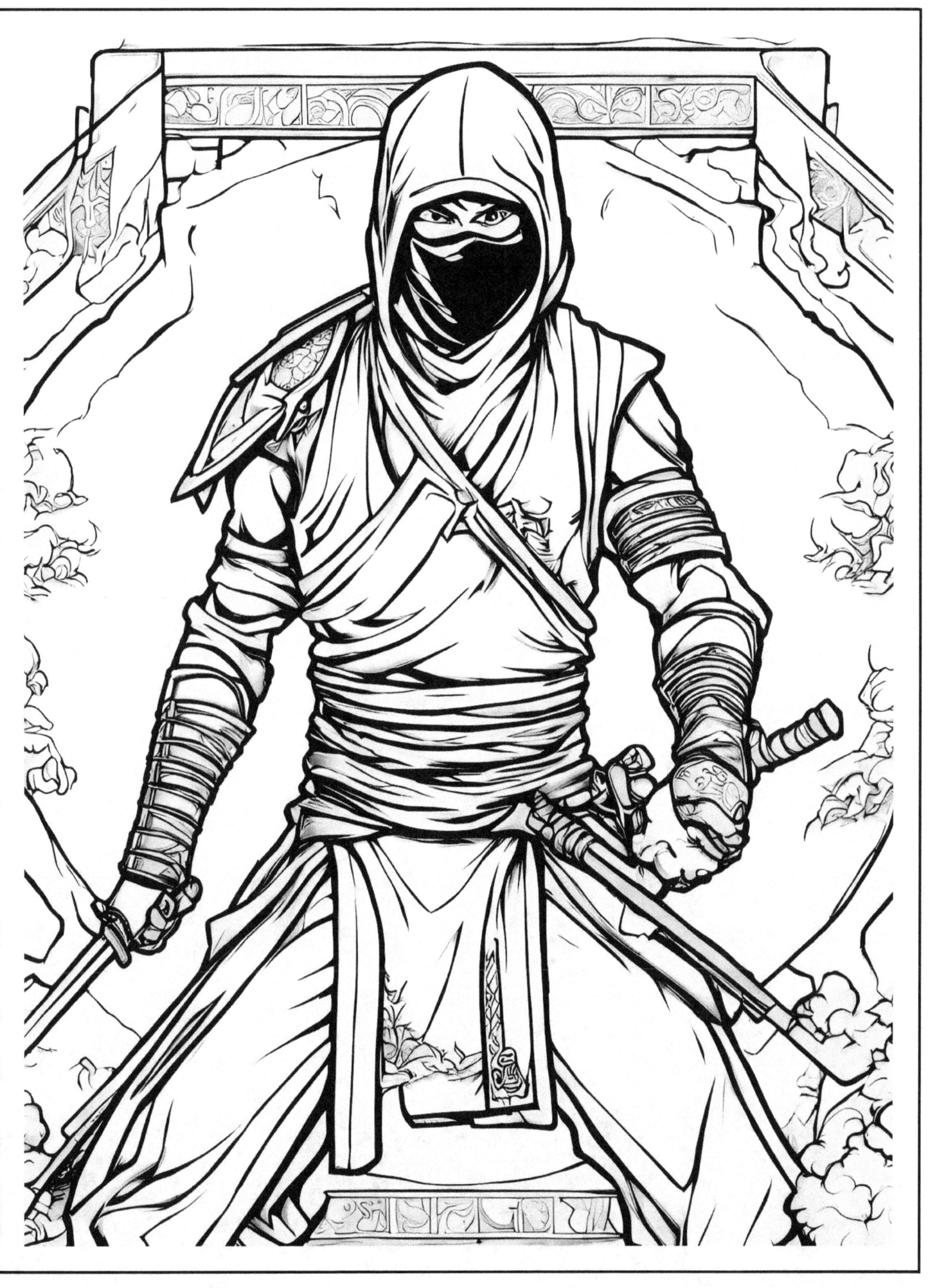

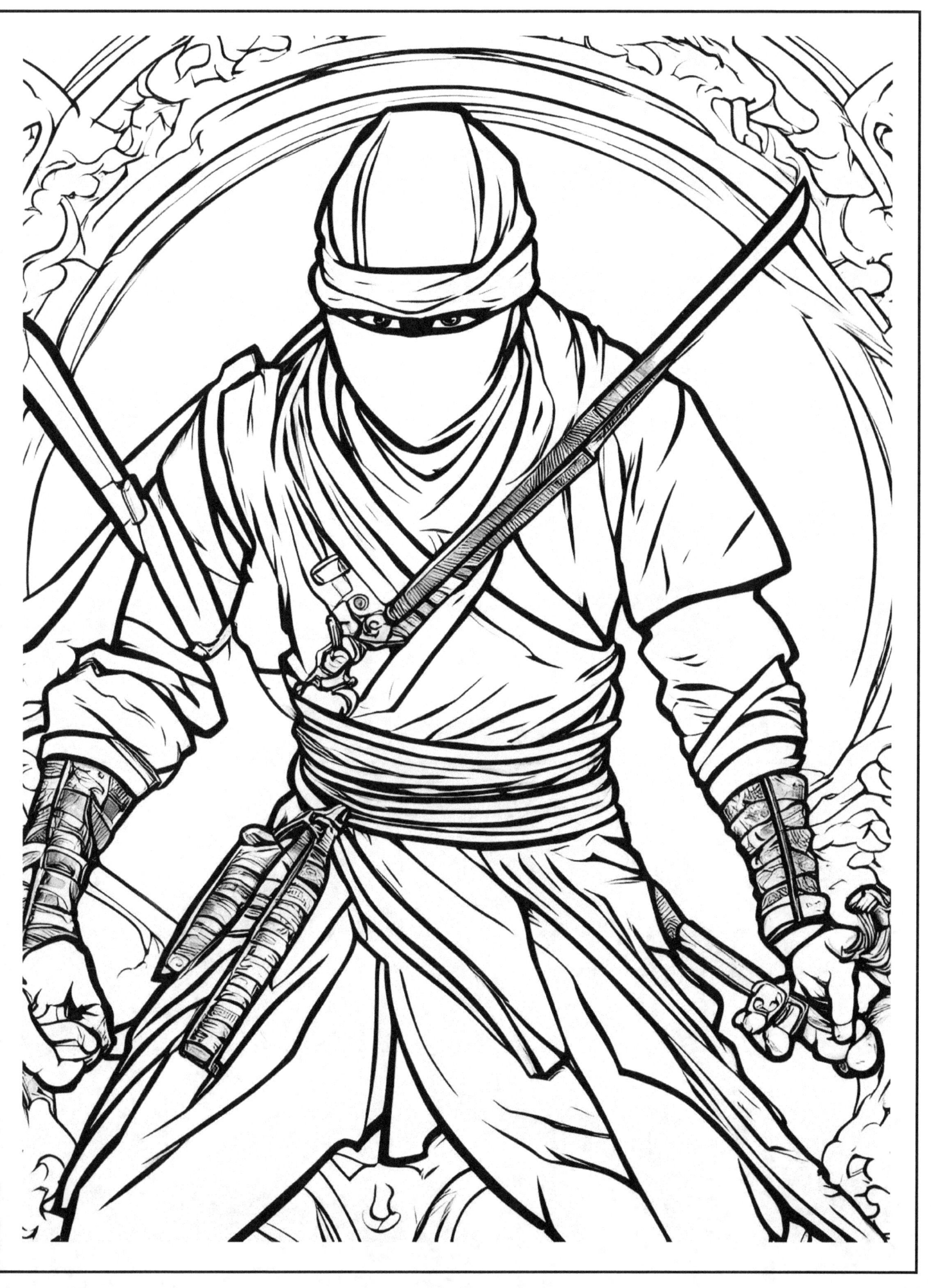

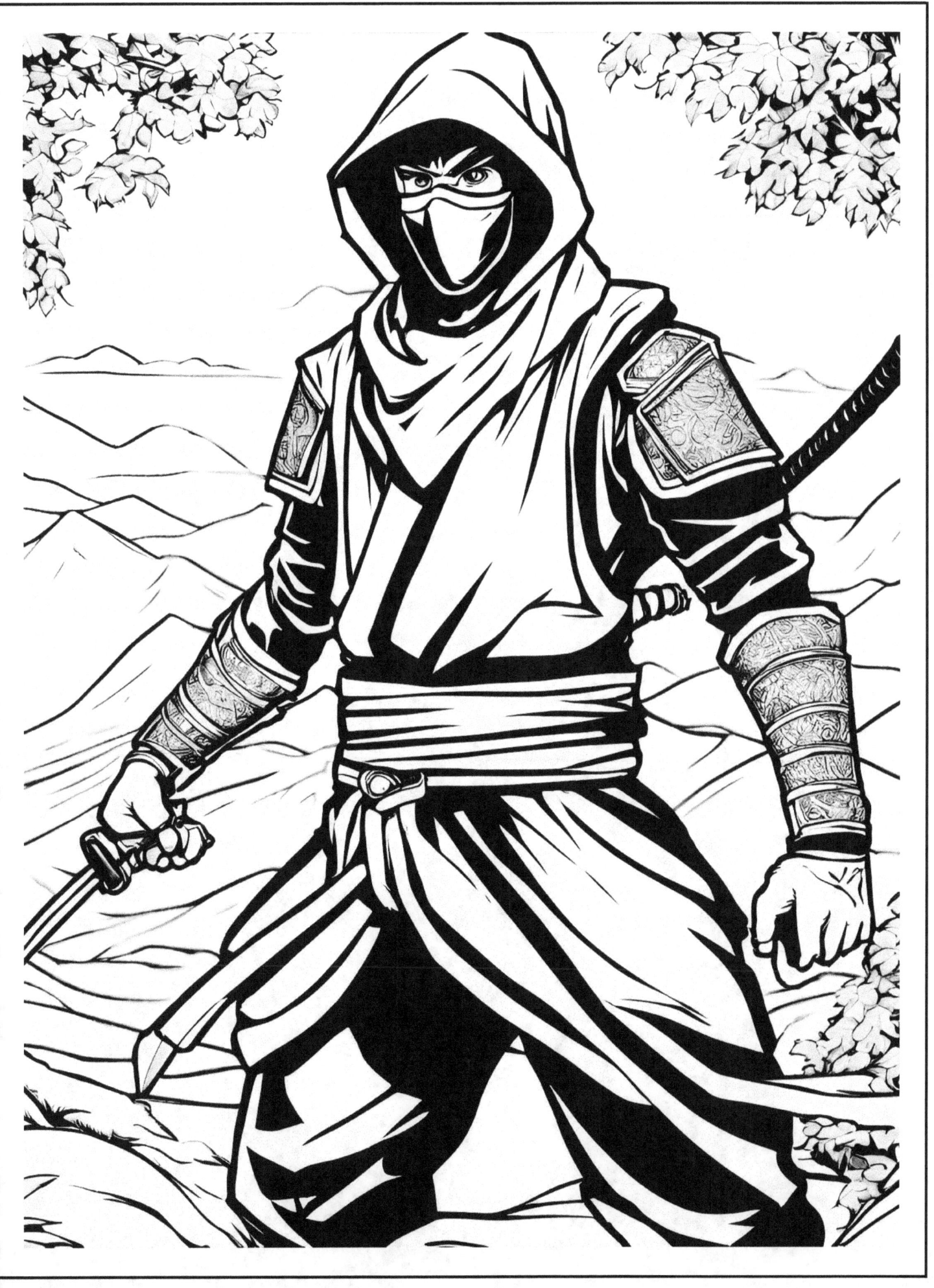

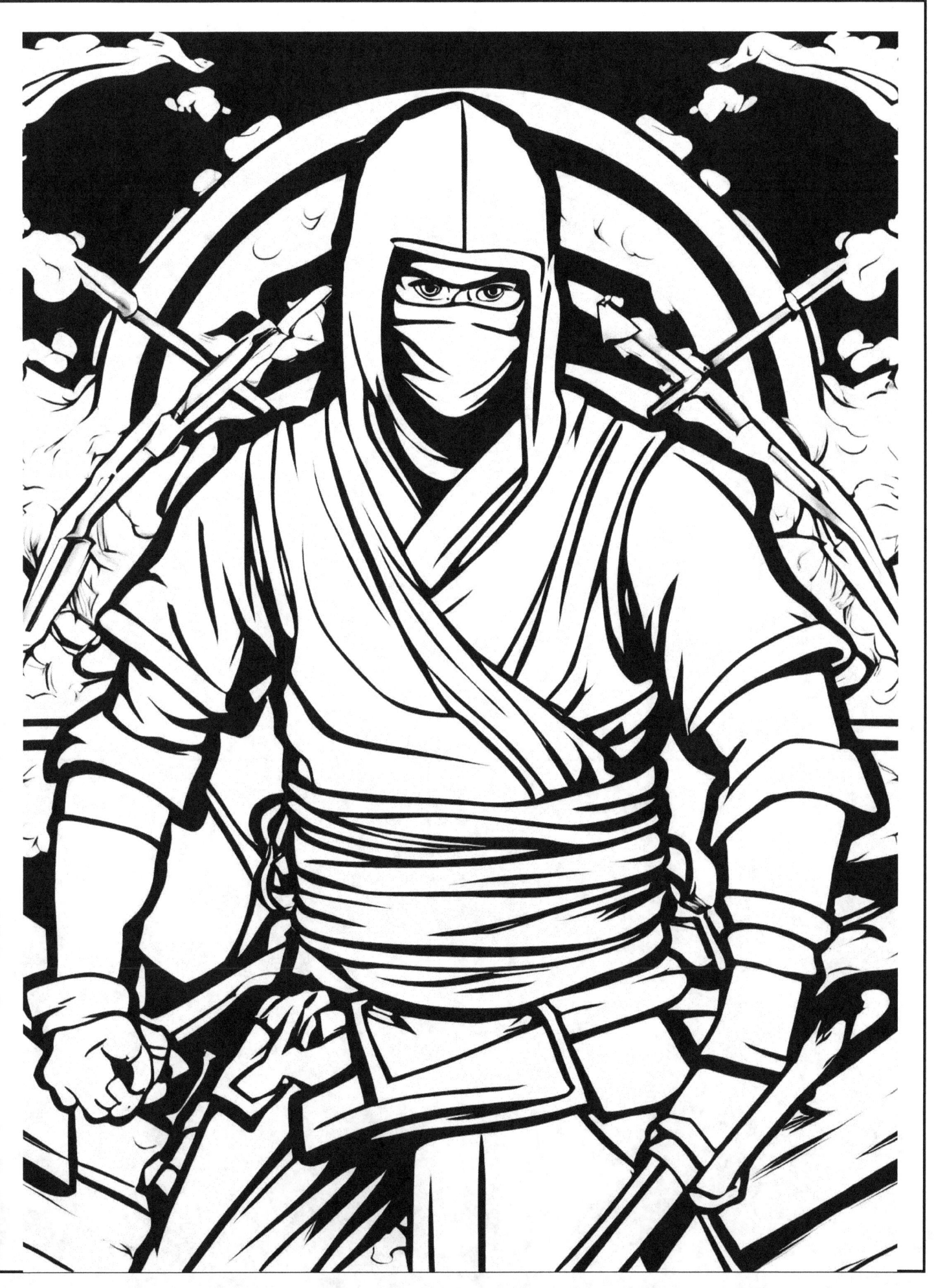

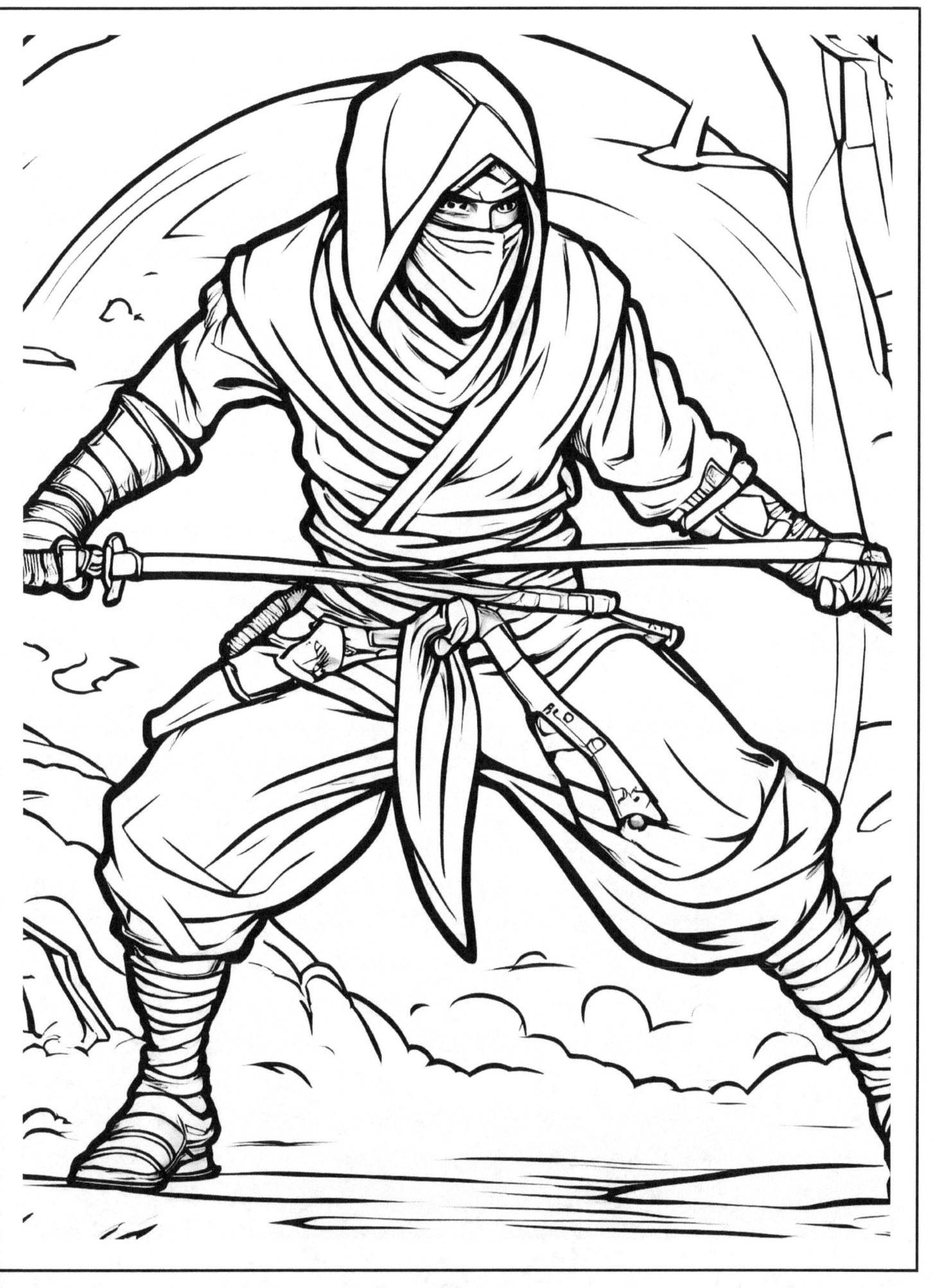

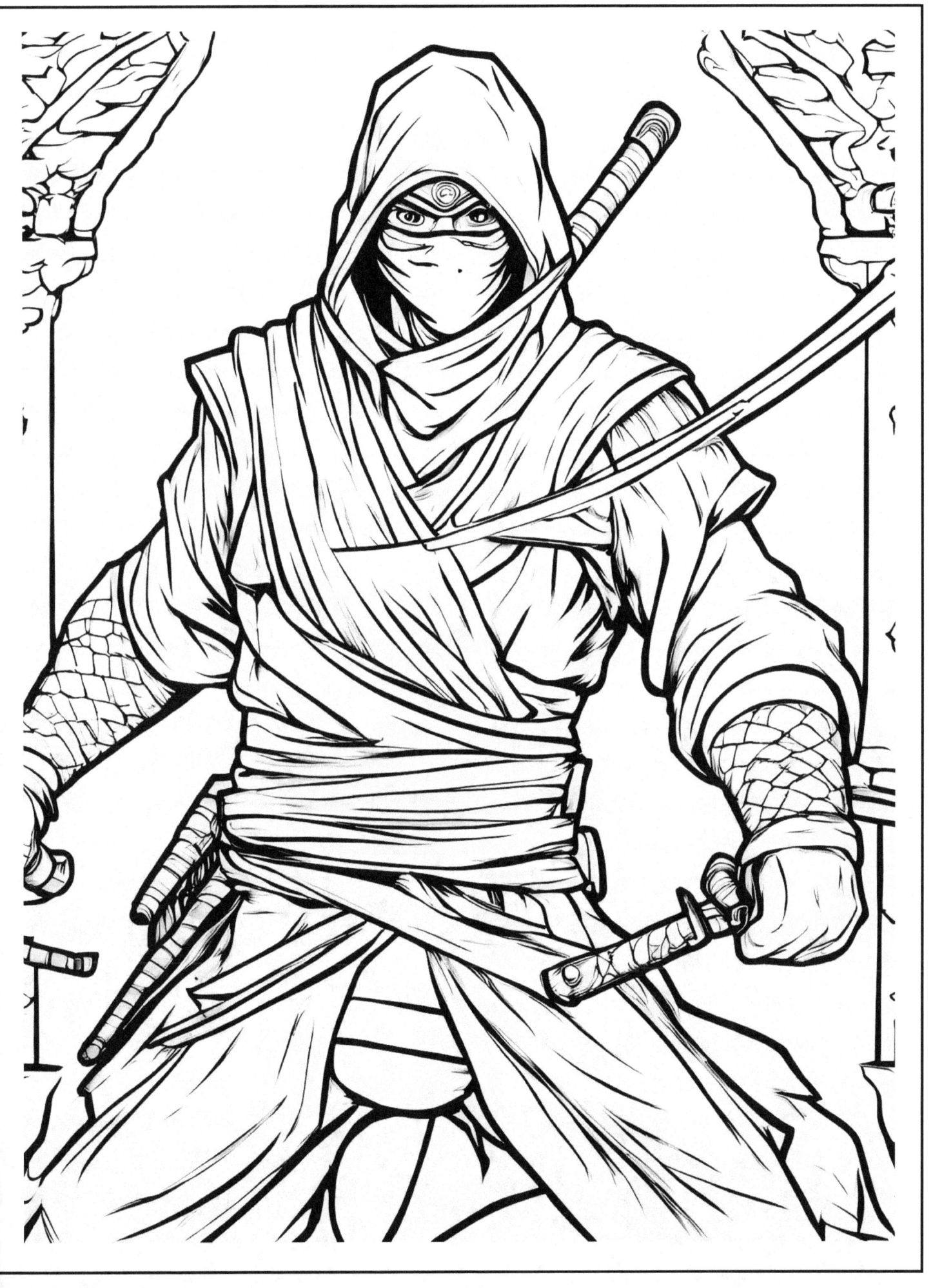

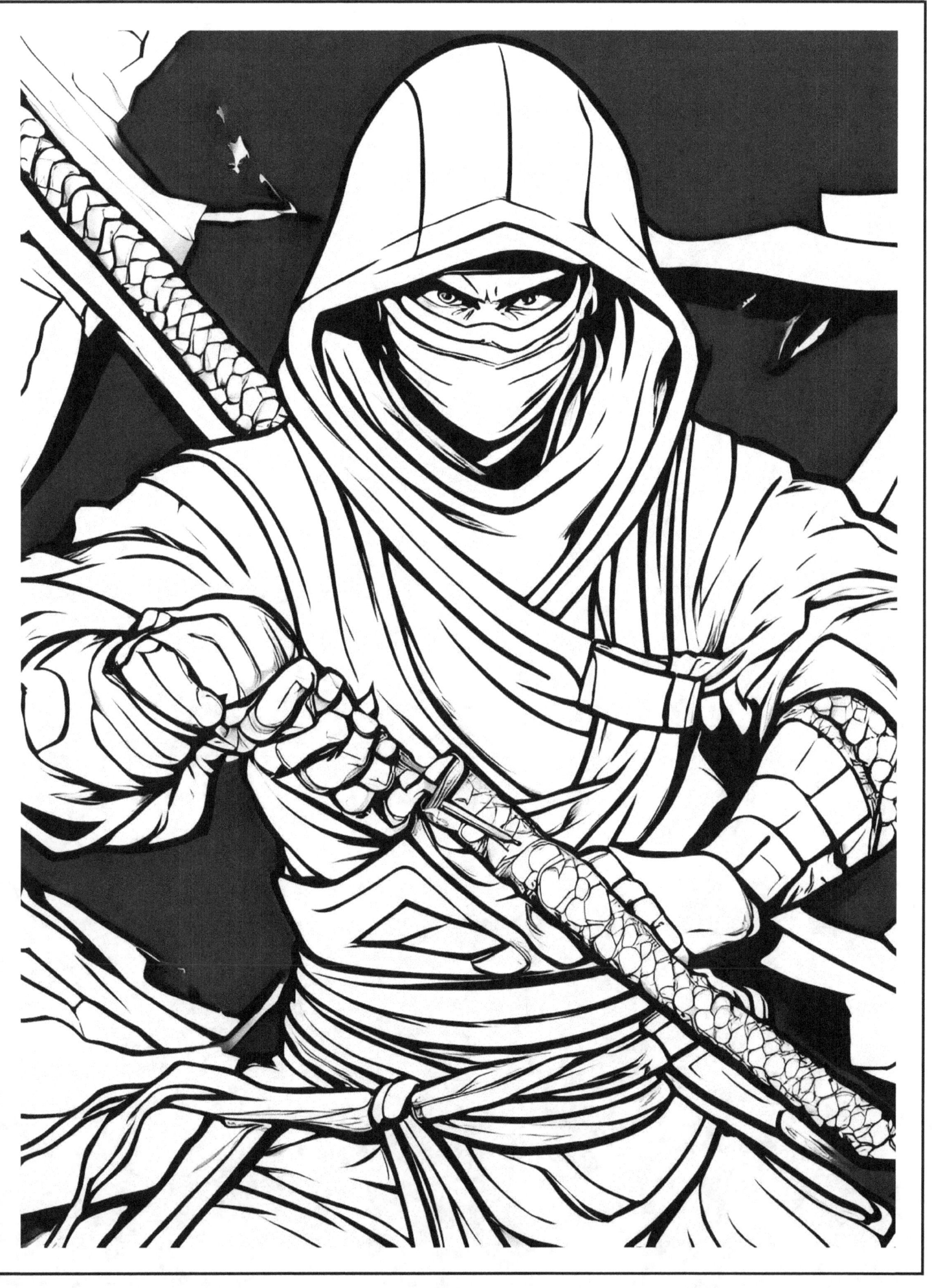

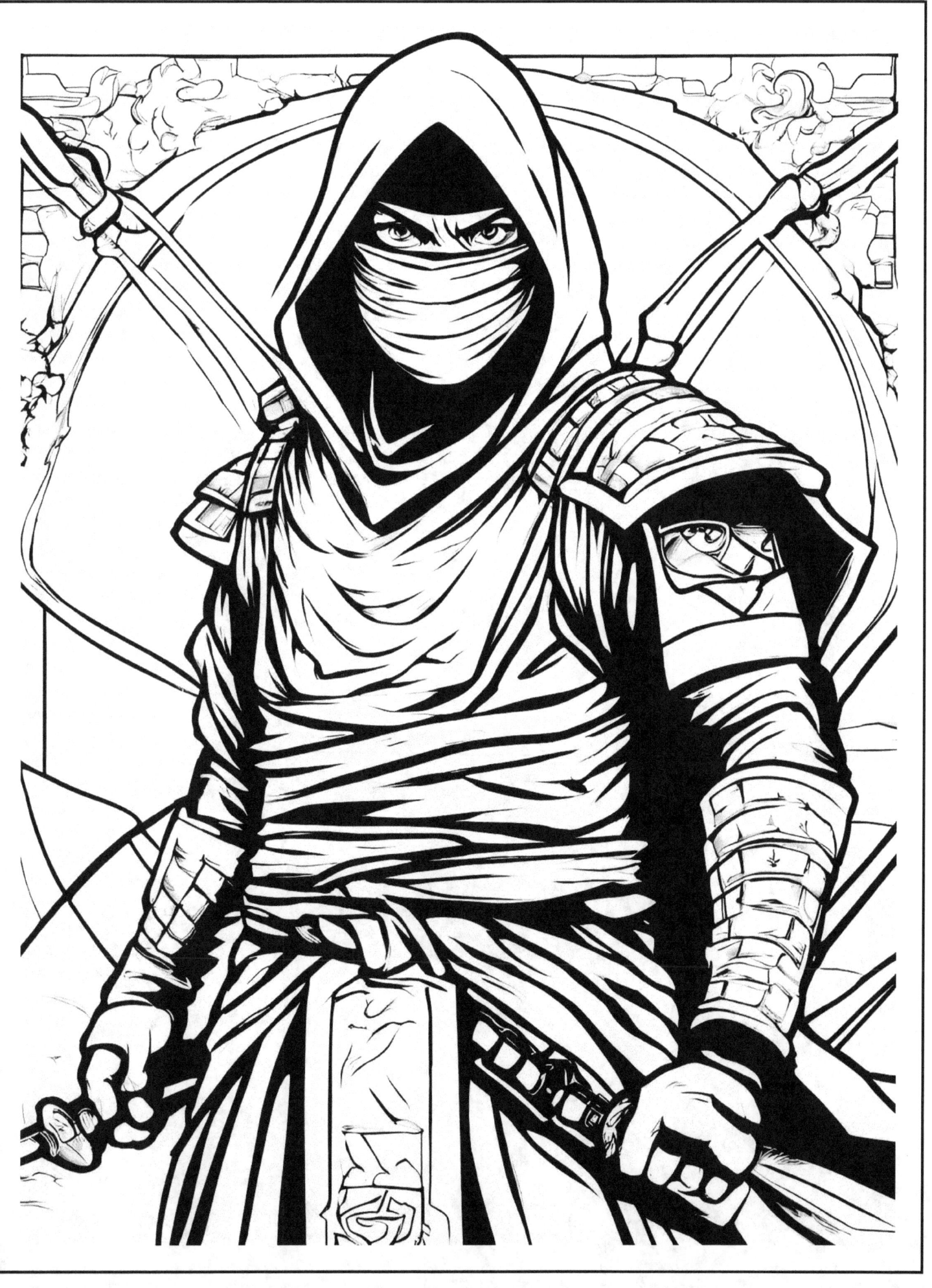

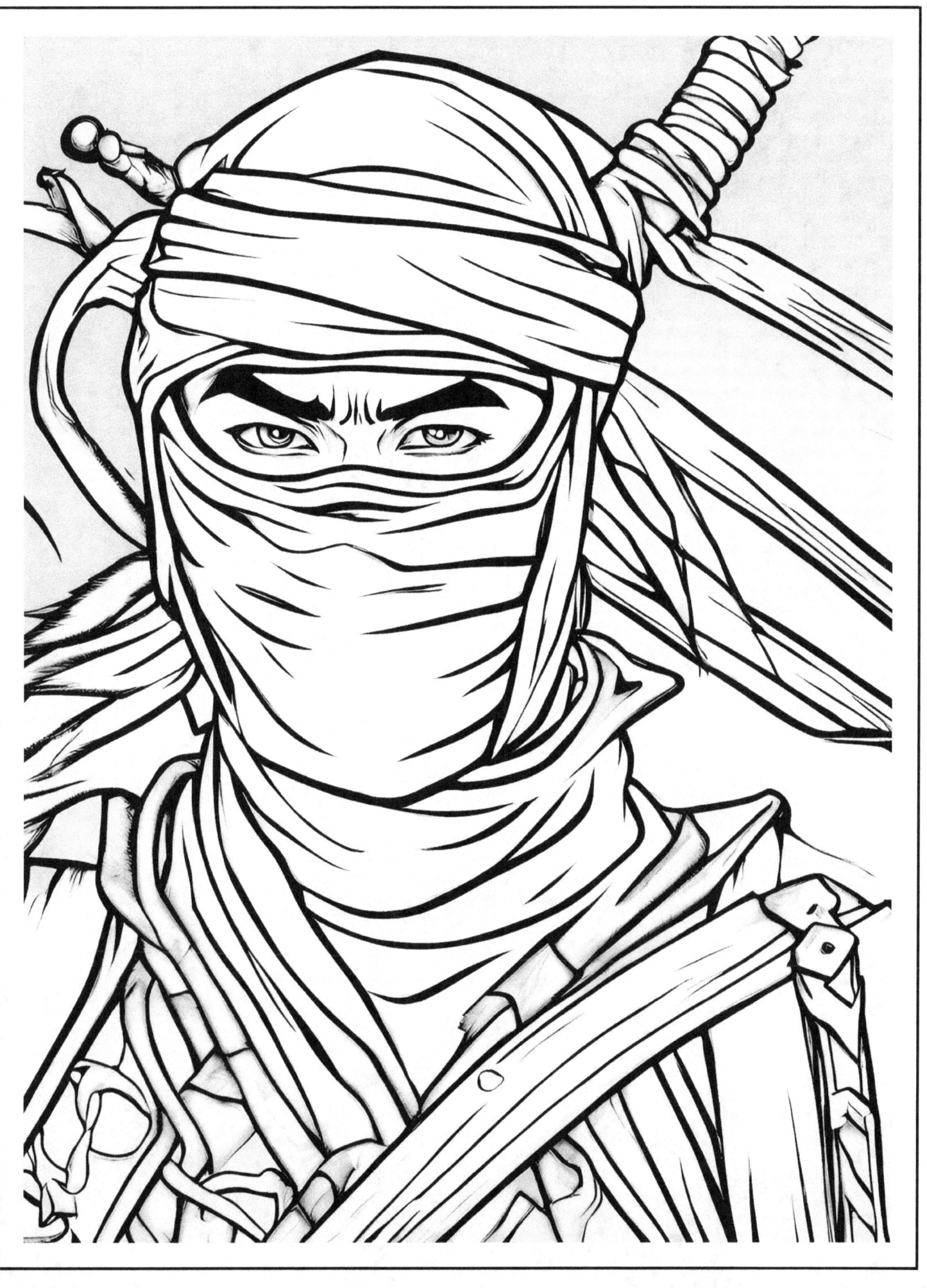

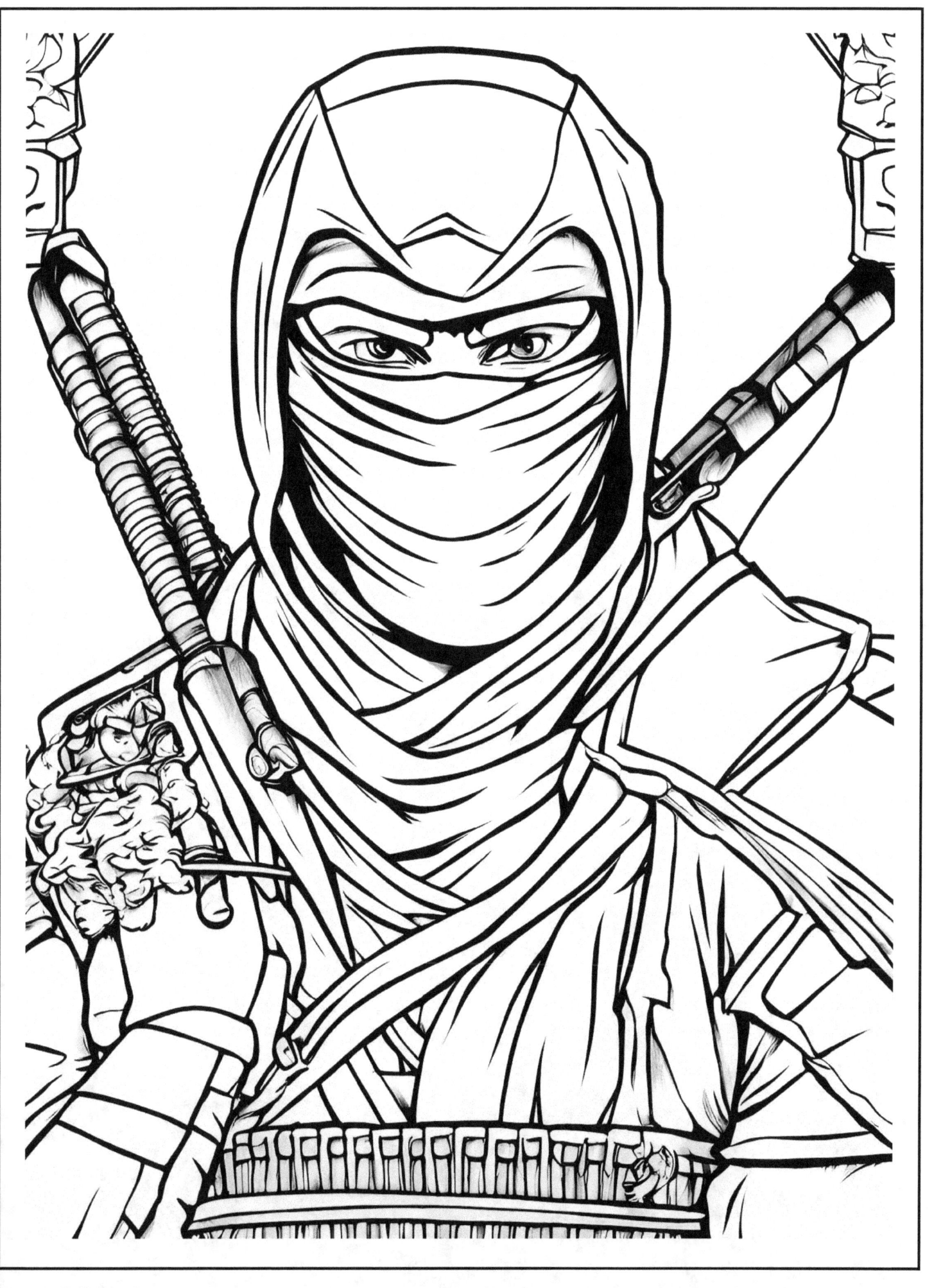

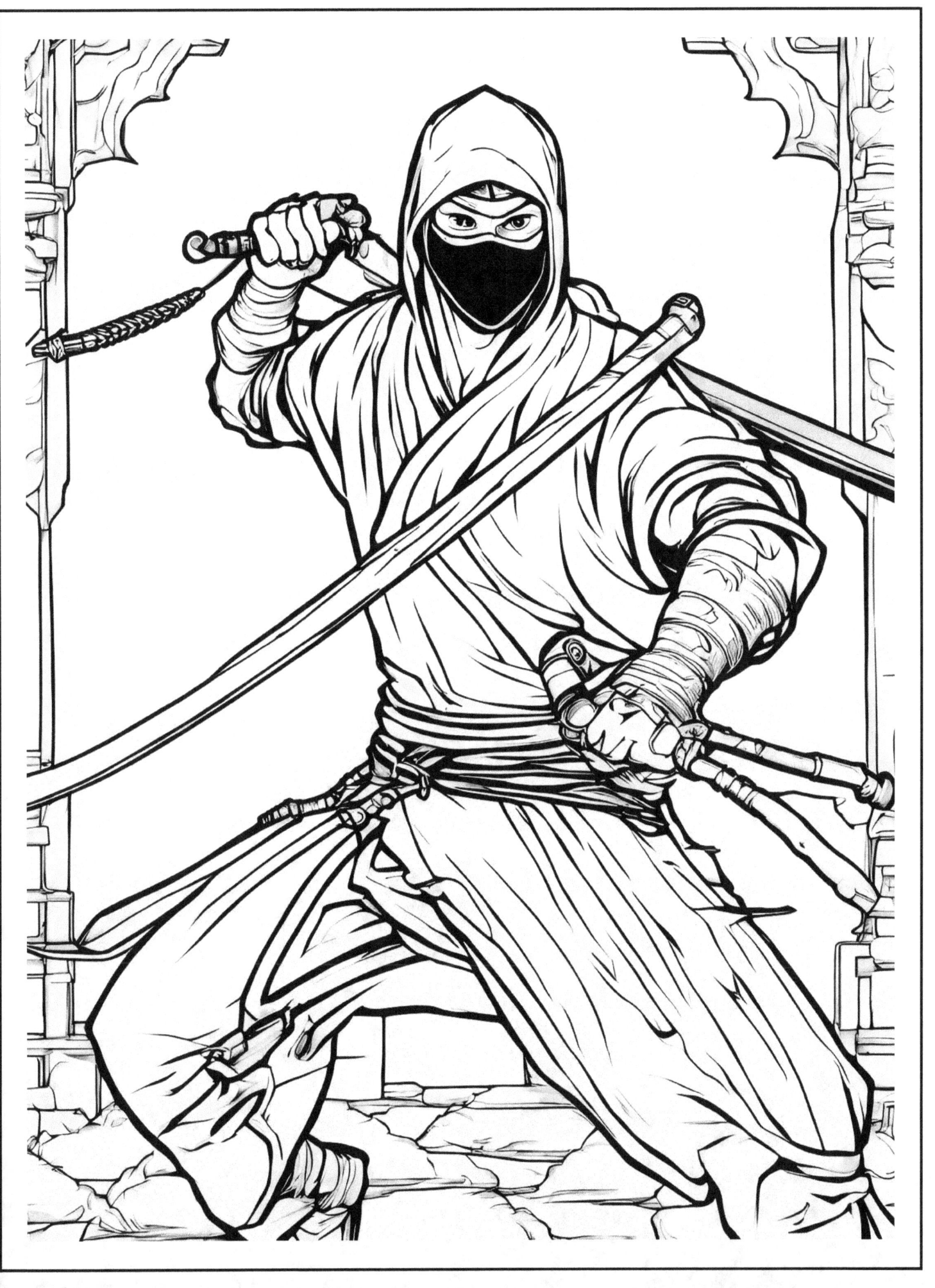

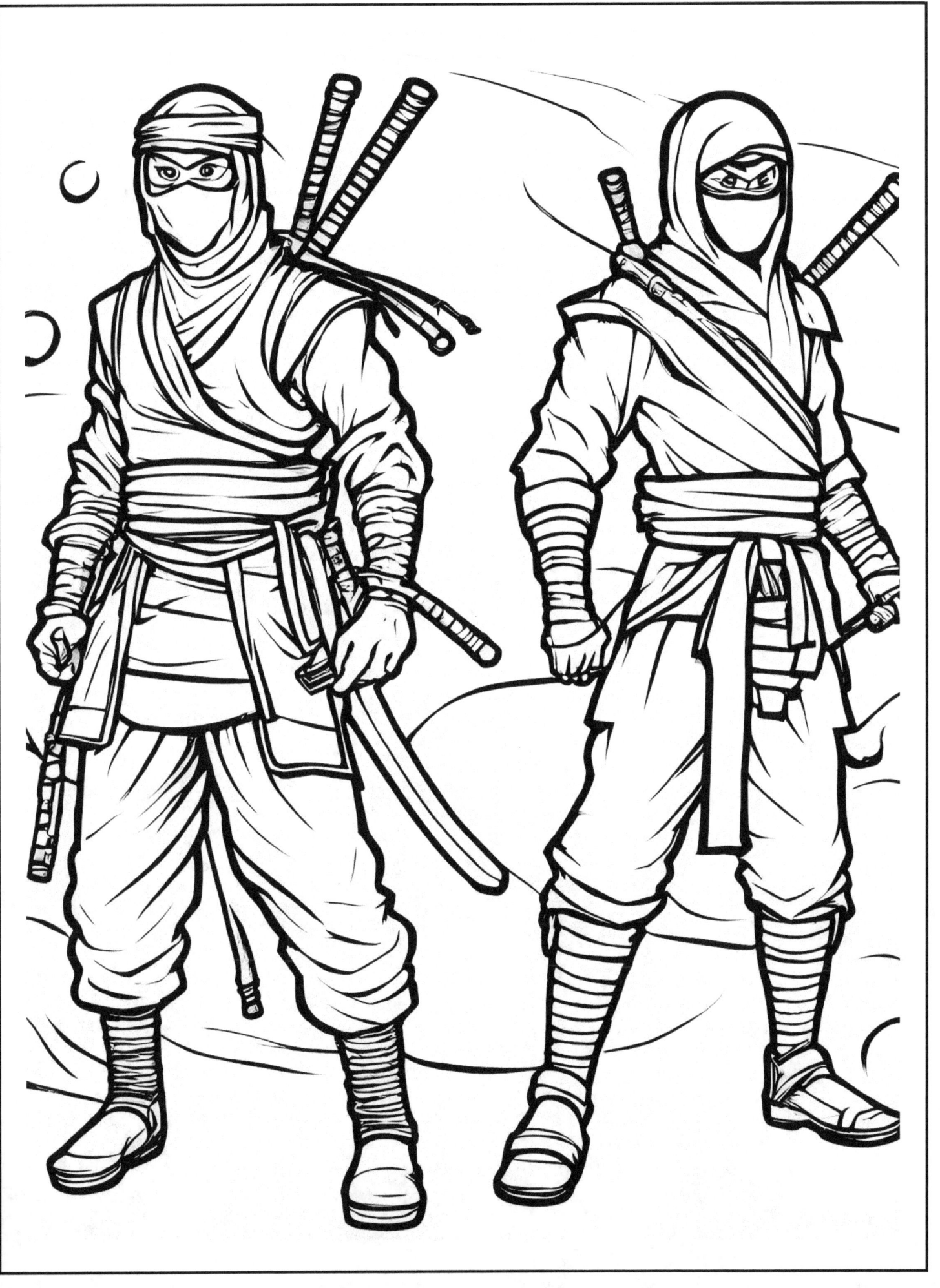

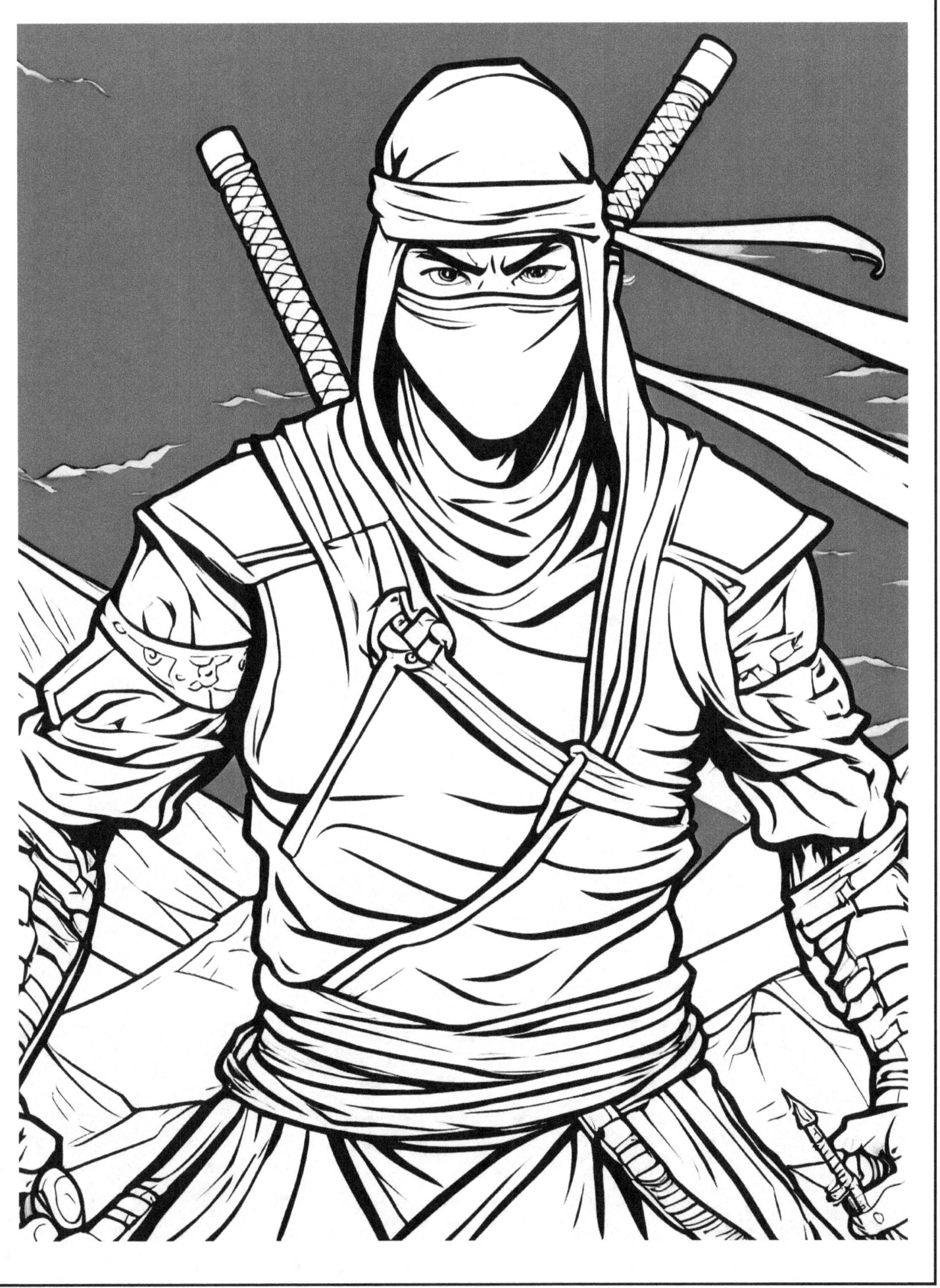

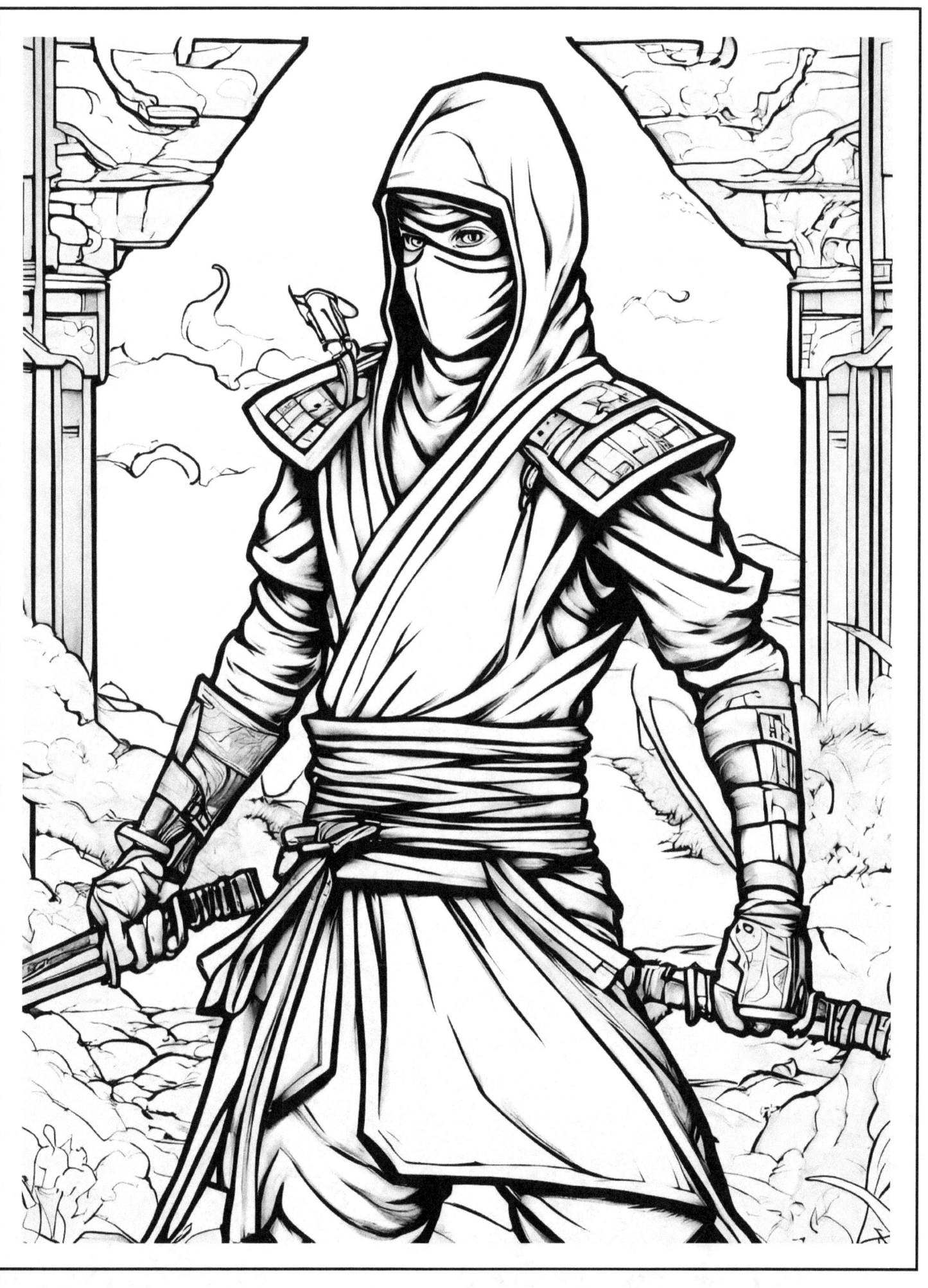

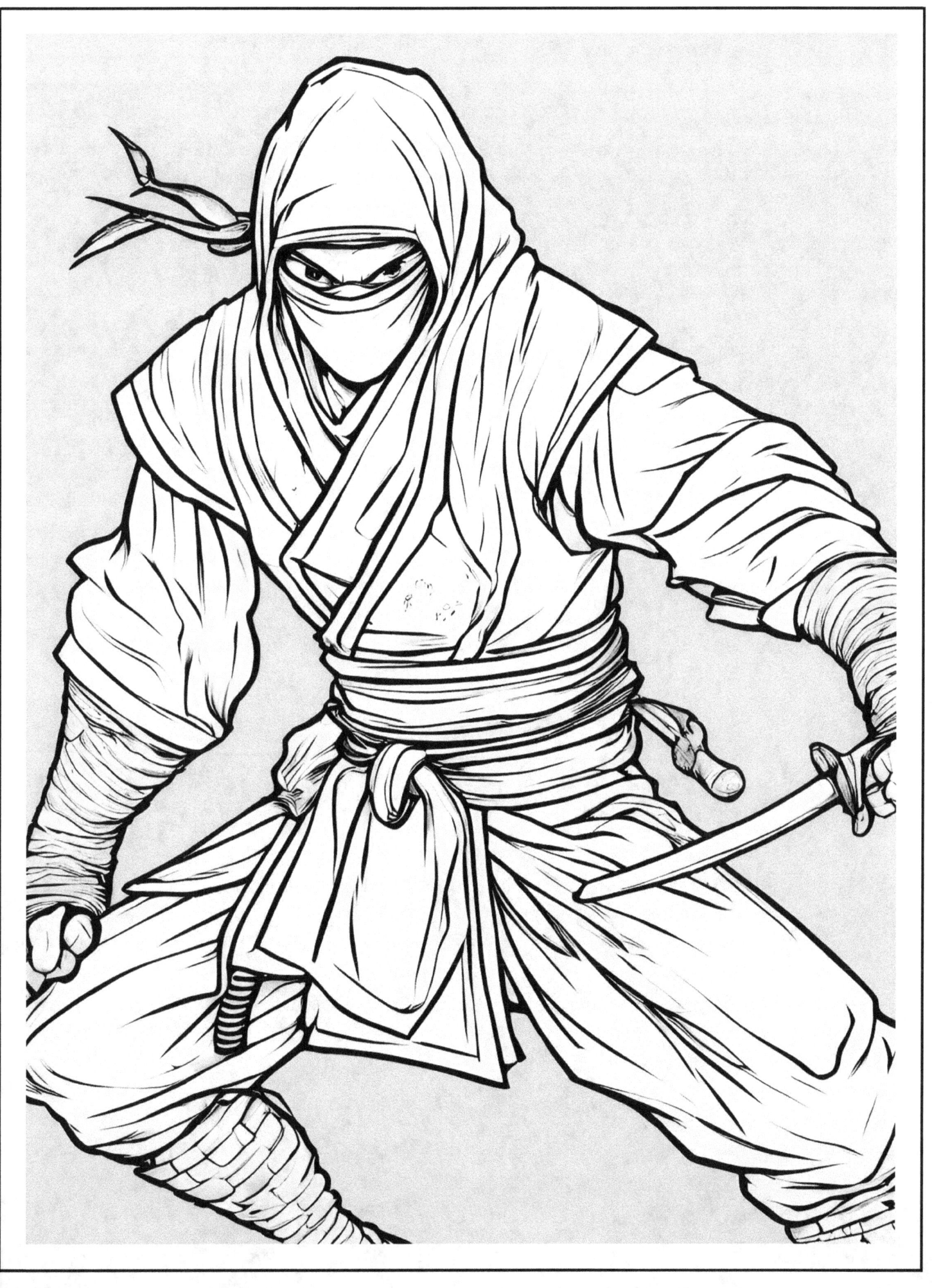

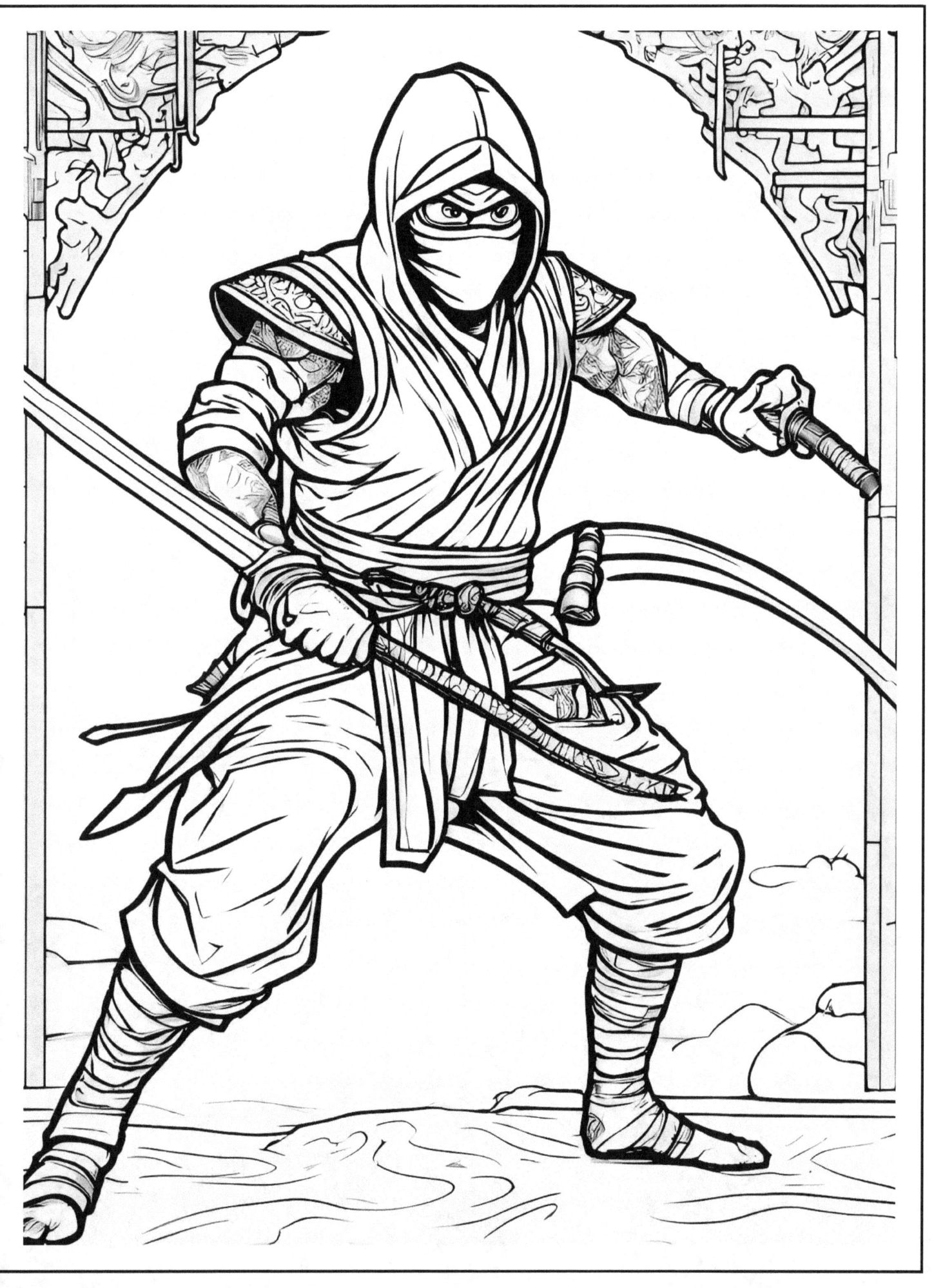

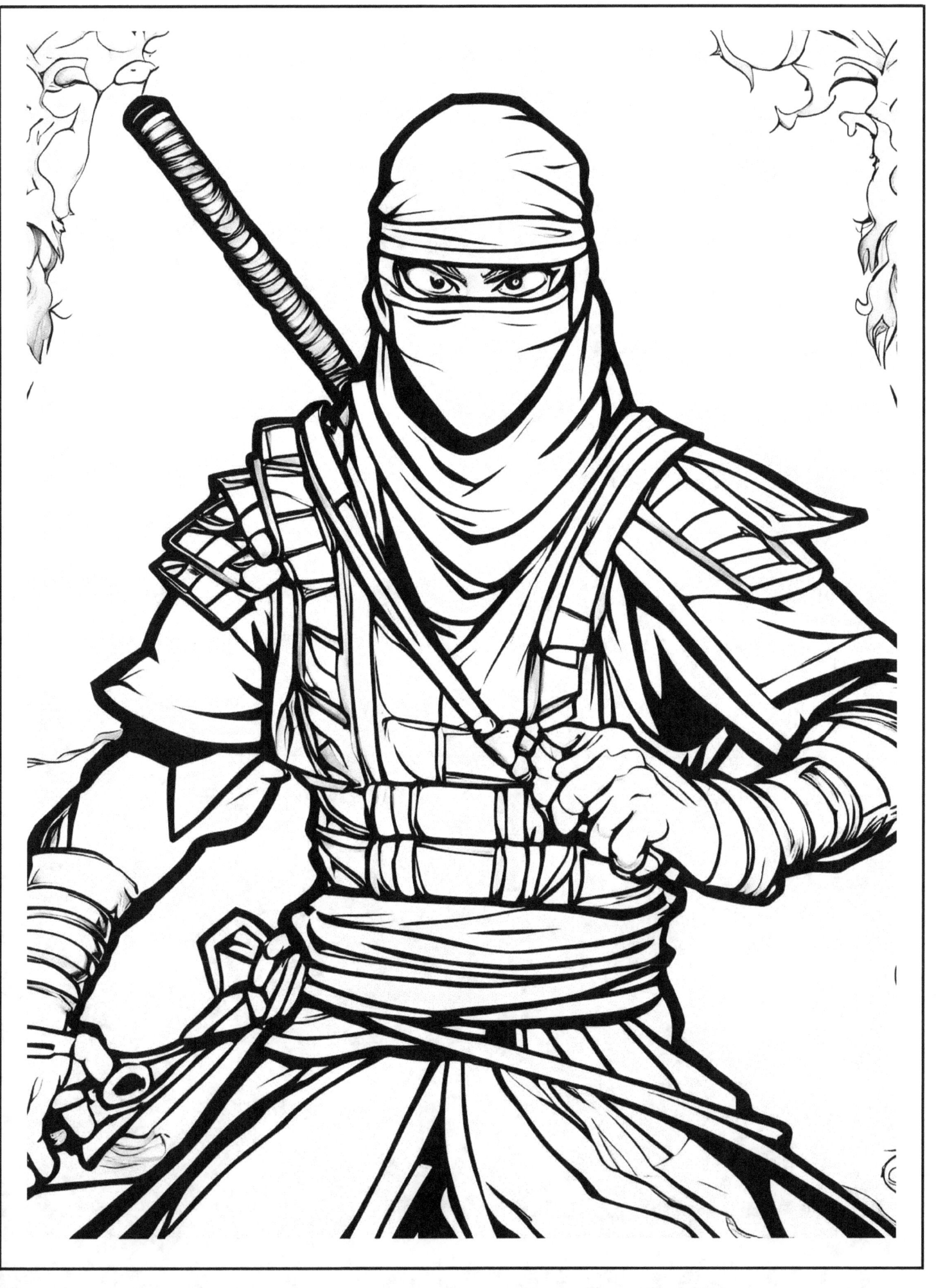

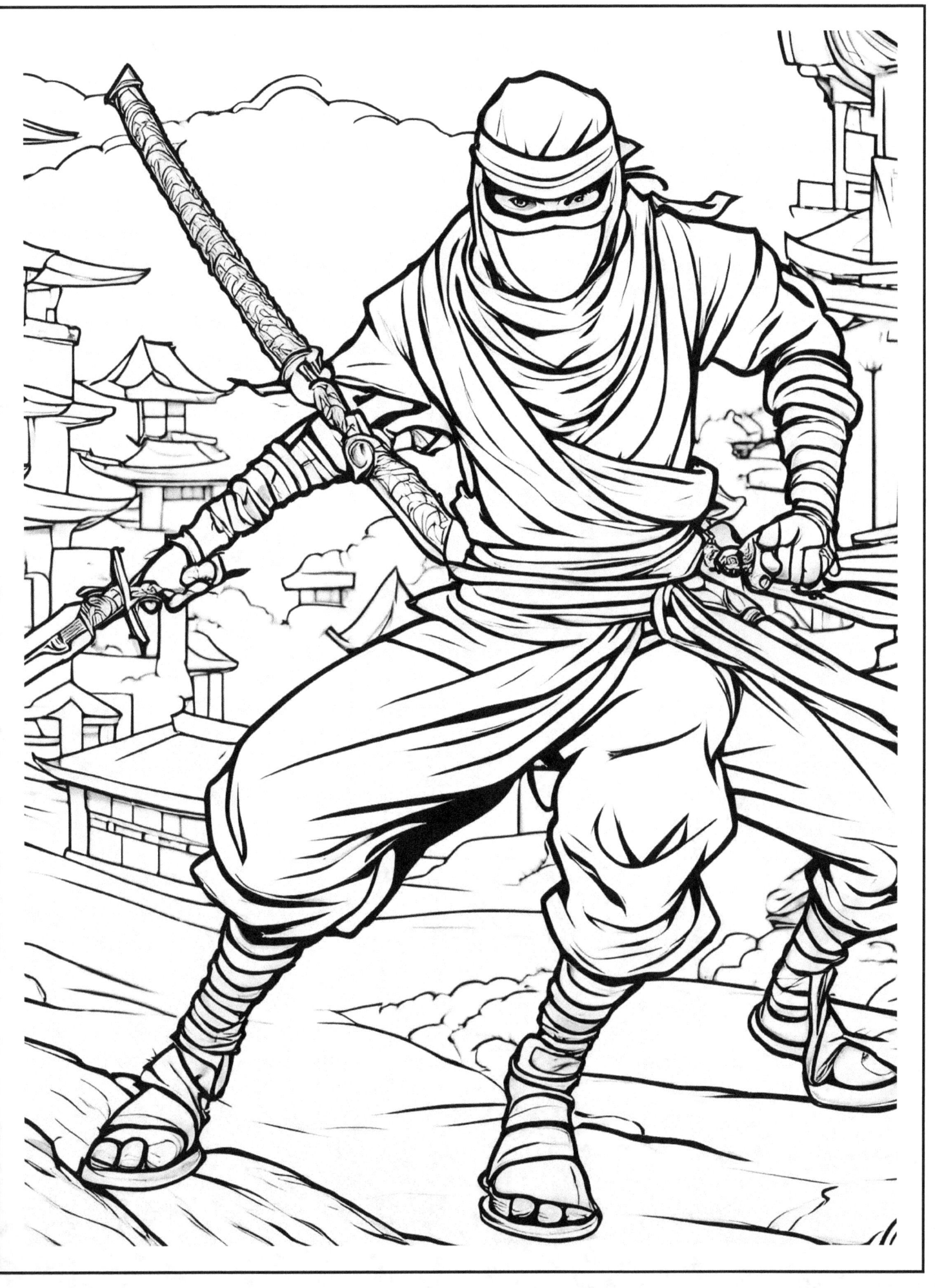

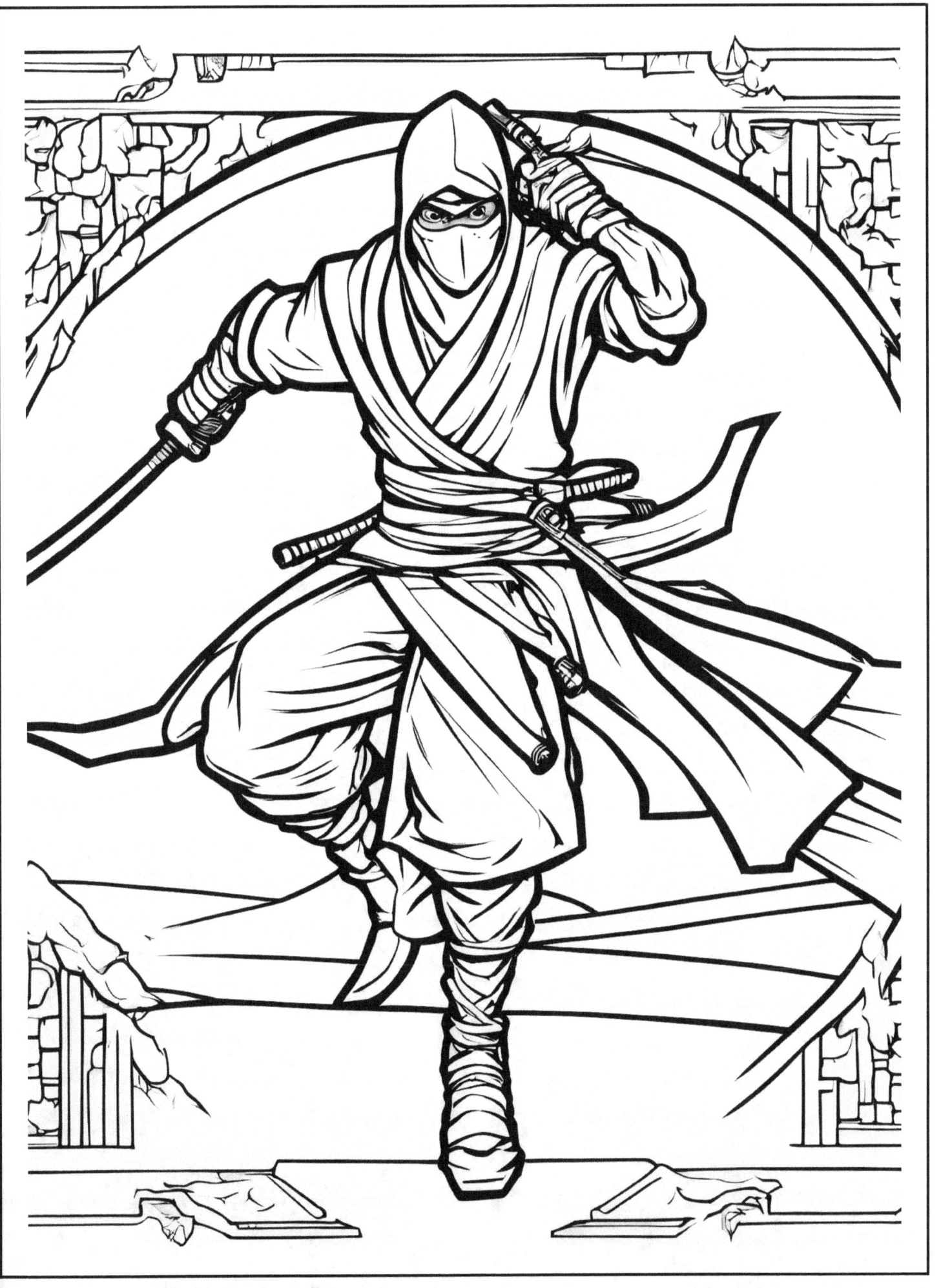

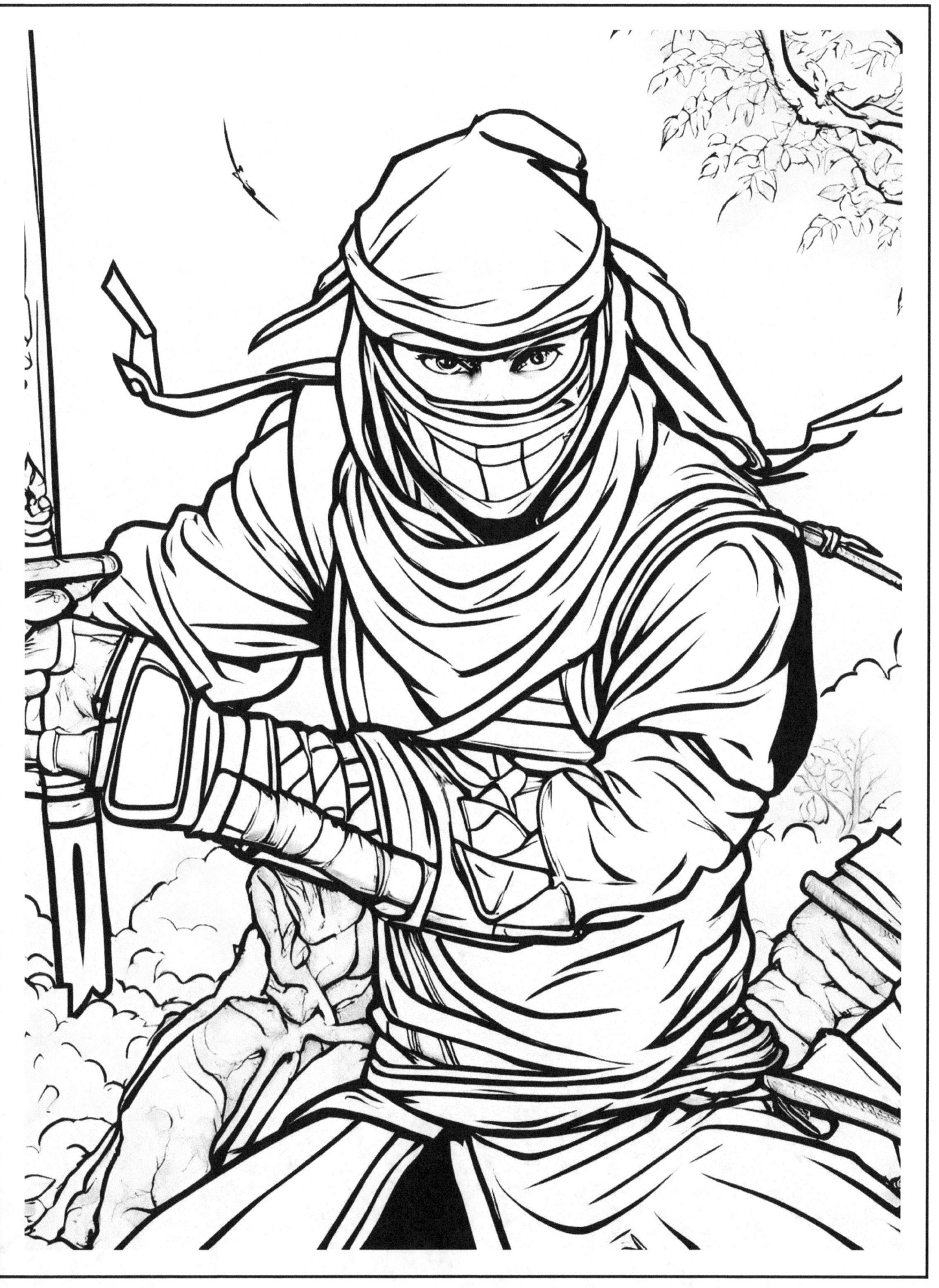

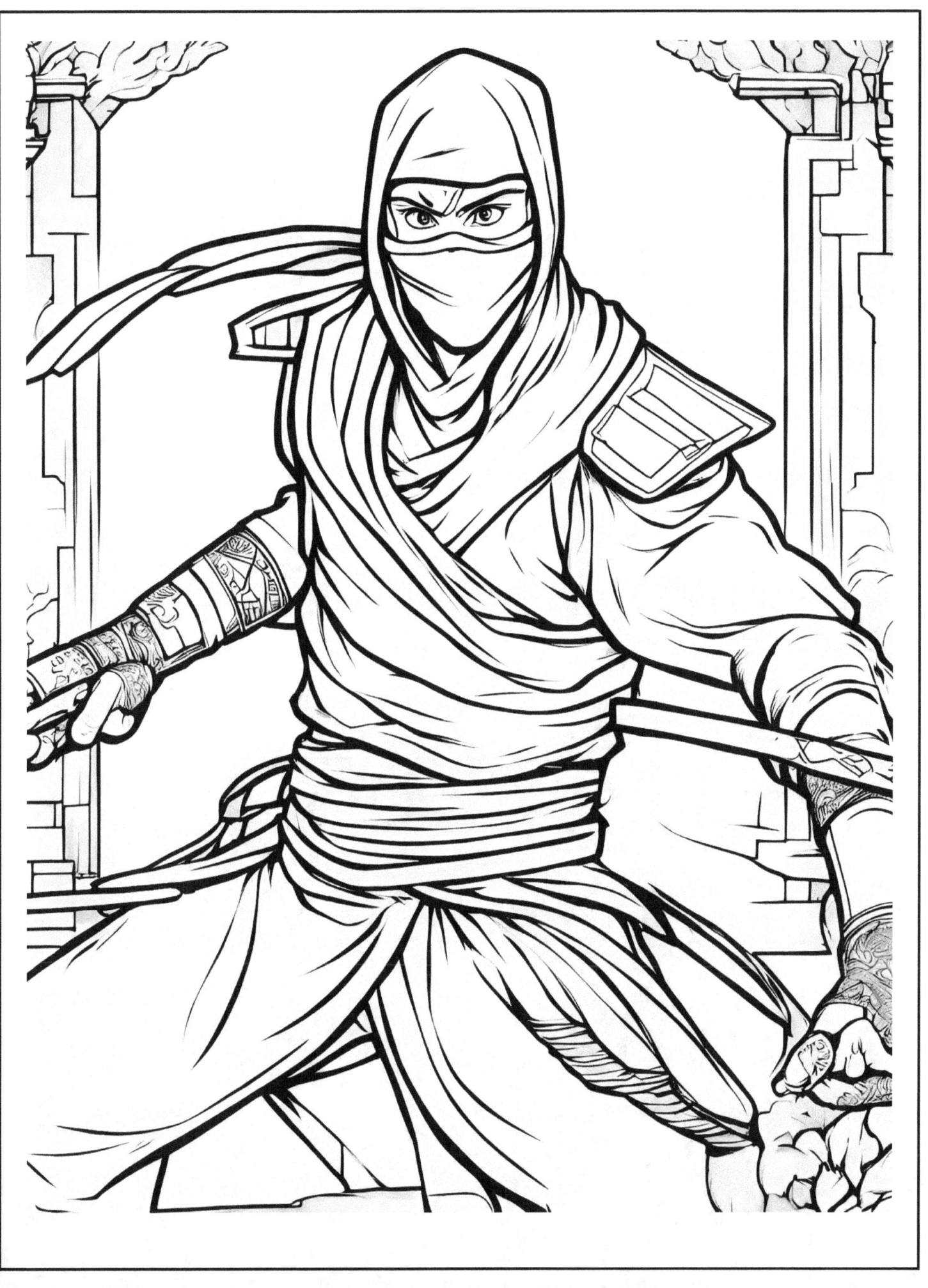

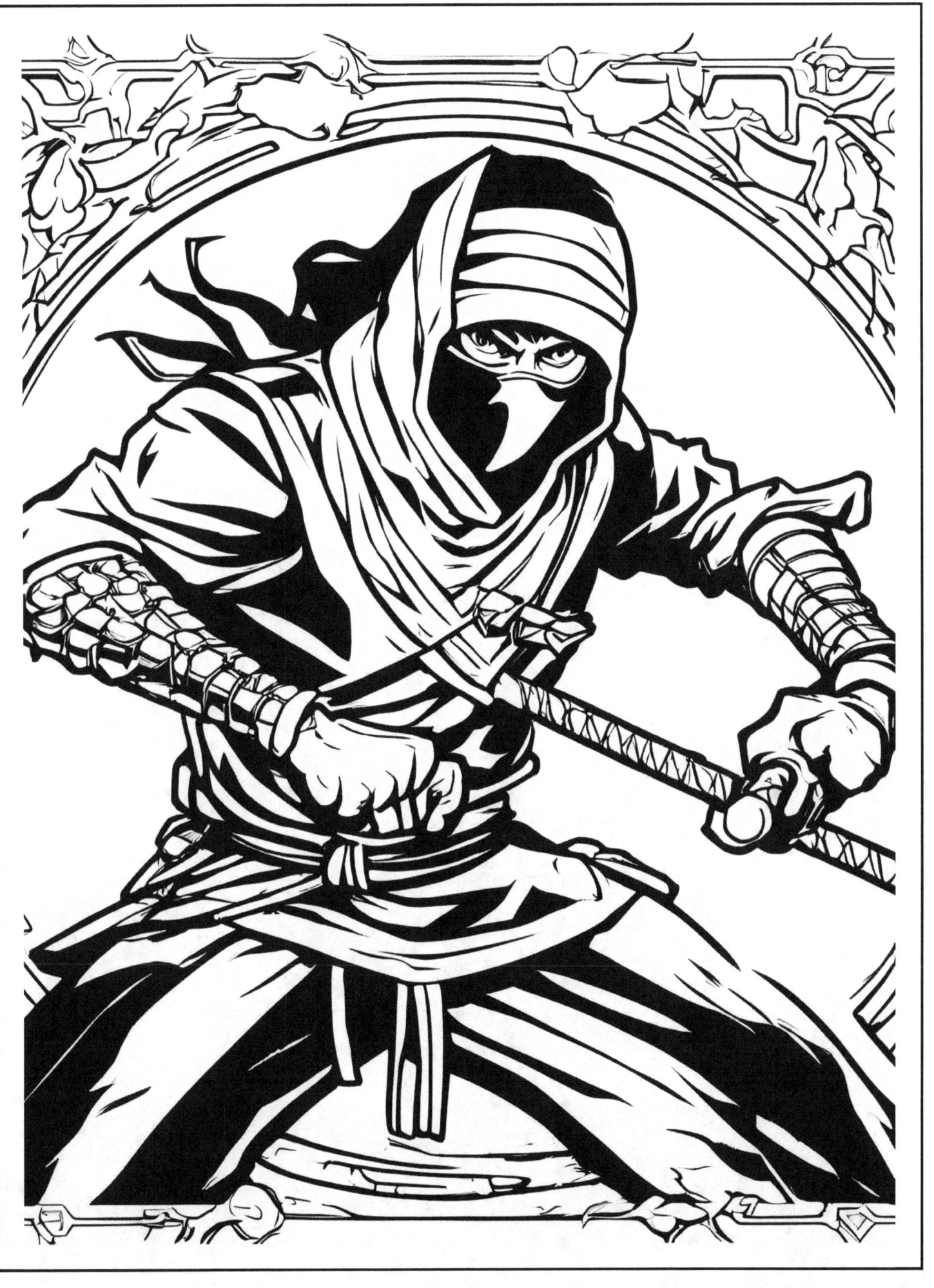

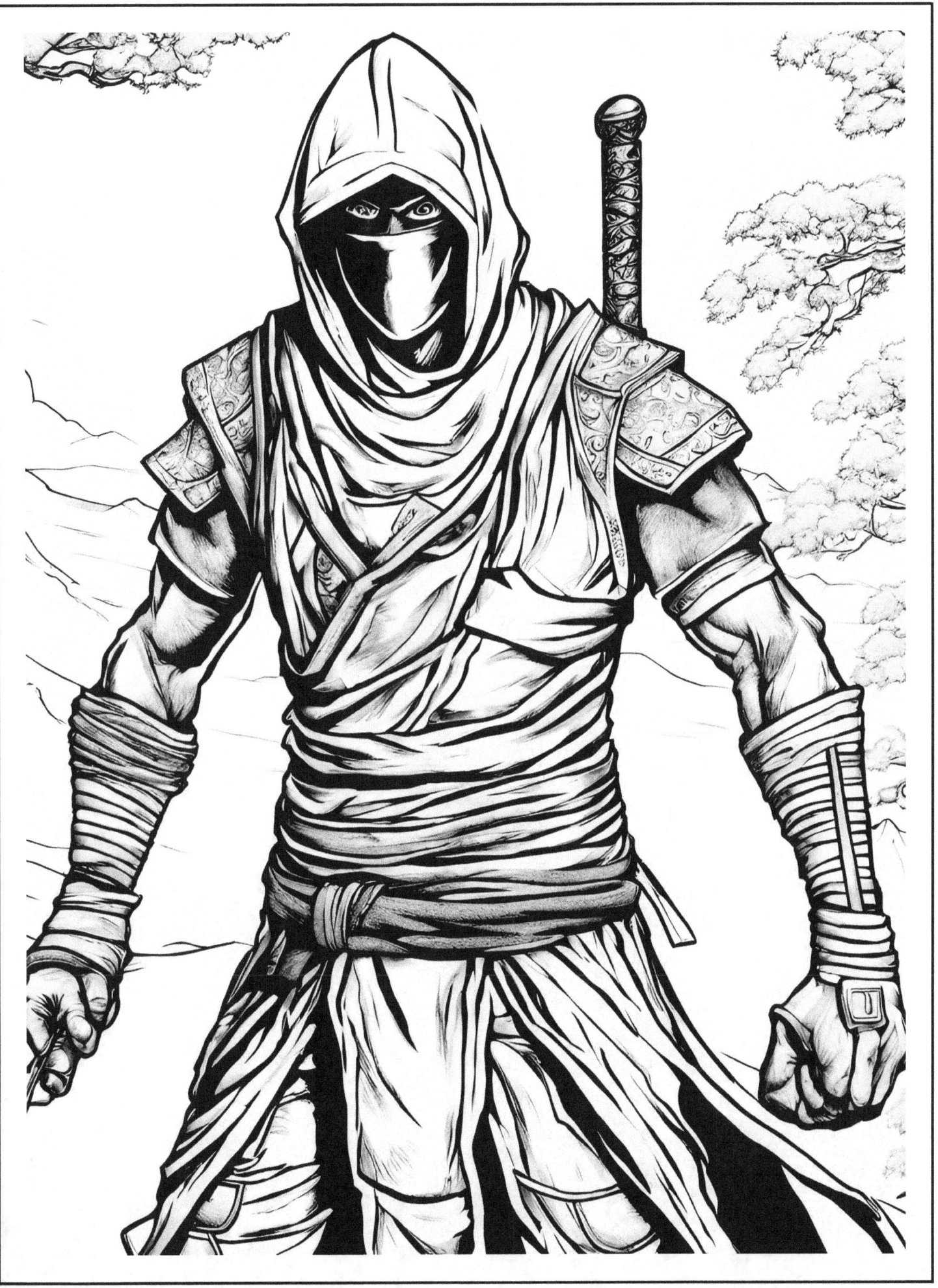

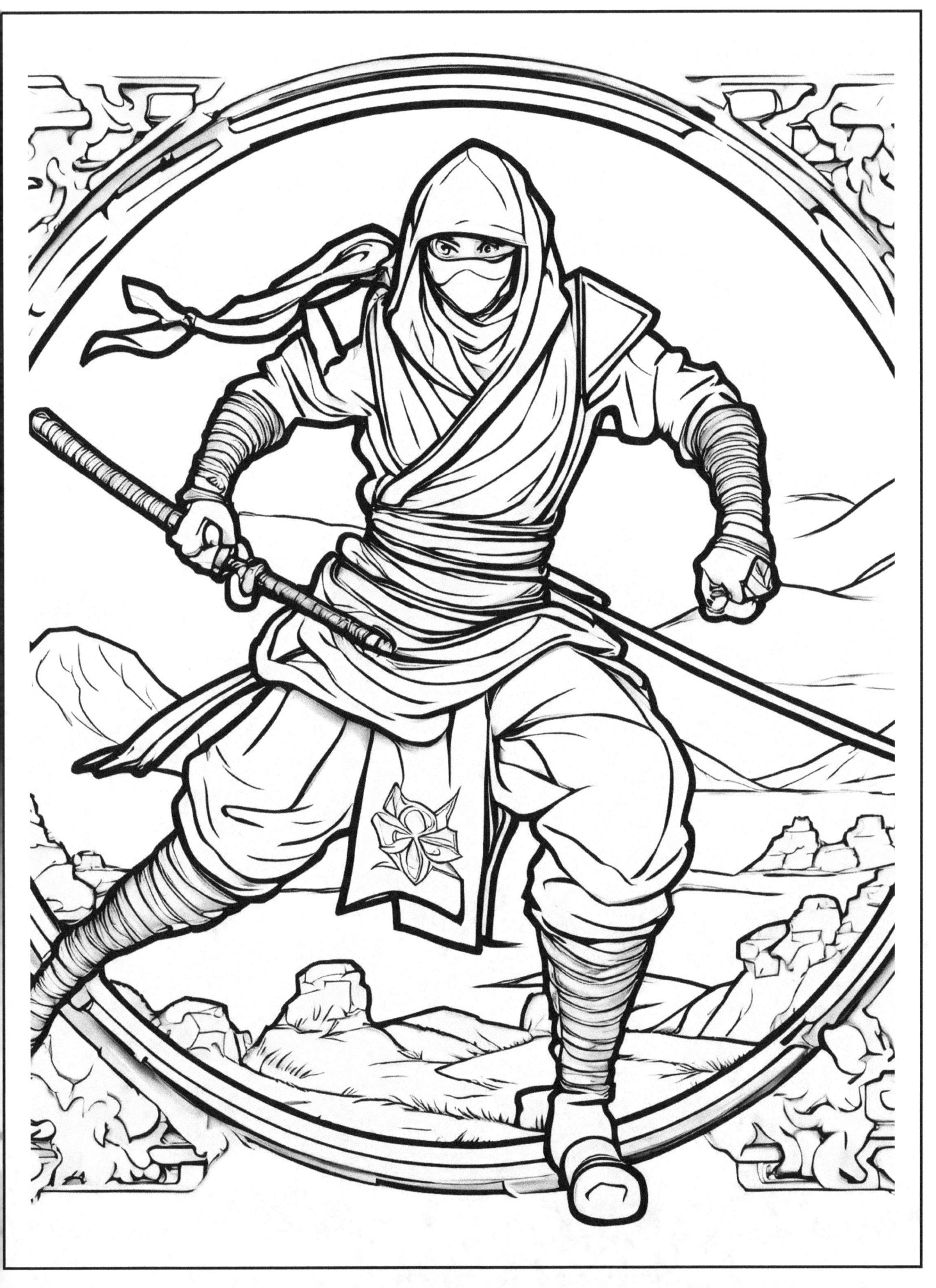

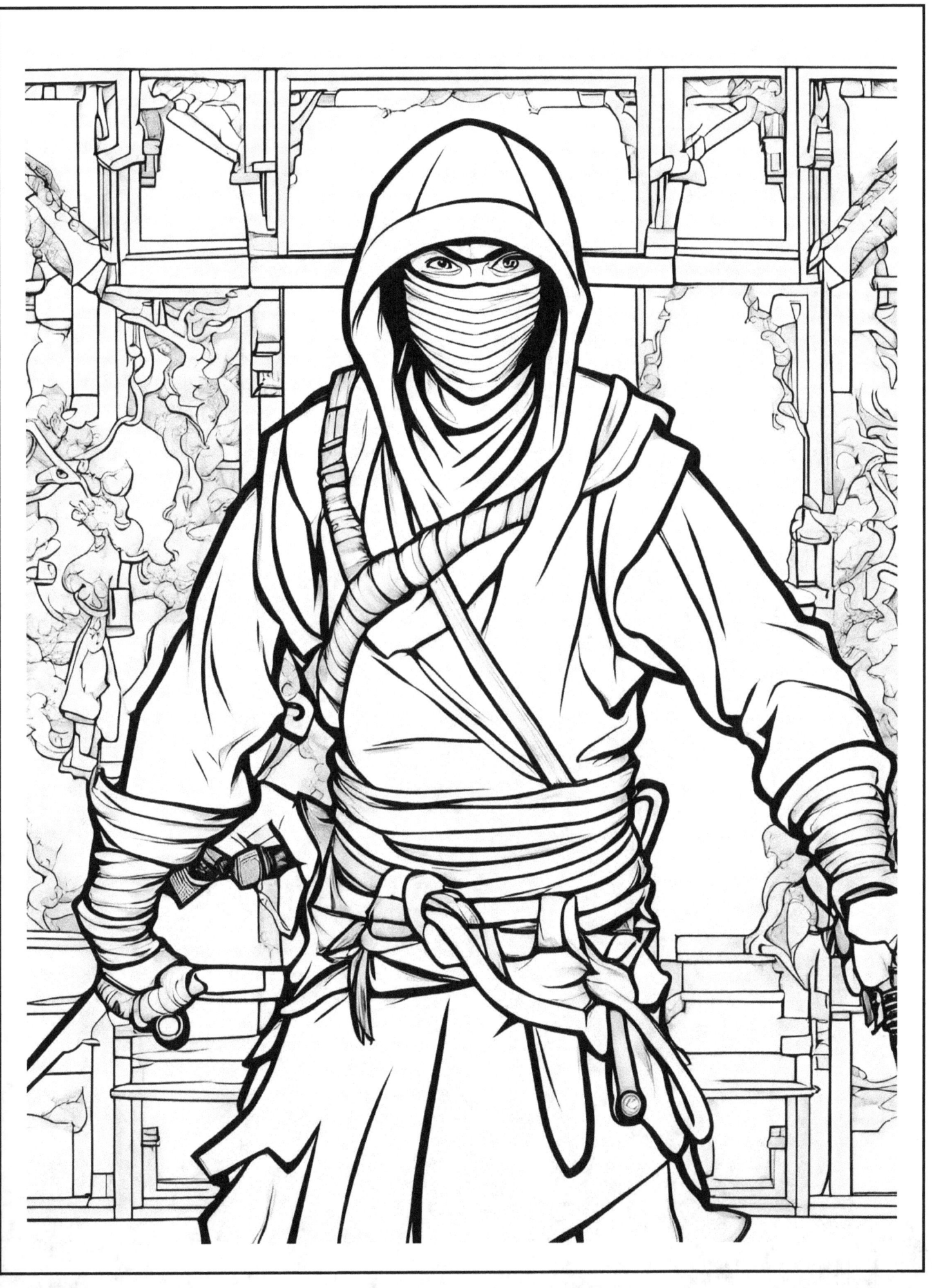

www.ingramcontent.com/pod-product-compliance
Lightning Source LLC
Chambersburg PA
CBHW082237220526
45479CB00005B/1261